GOTCHA DAY!

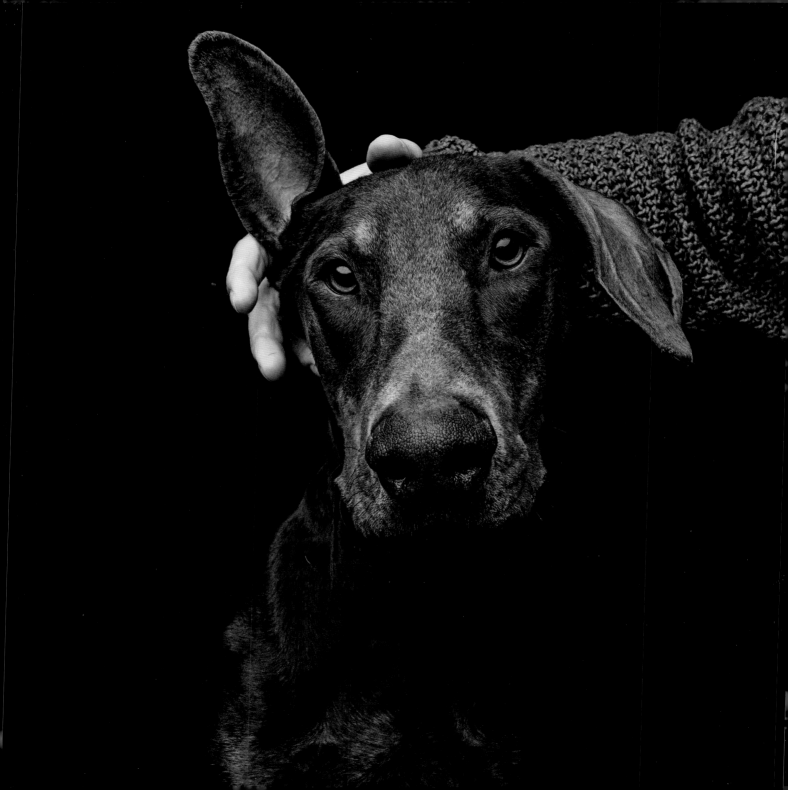

GOTCHA DAY!

ADOPTION TALES OF REMARKABLE RESCUE DOGS

PHOTOGRAPHS BY GREG MURRAY

FOREWORD BY DOUG TRATTNOR

Gibbs Smith

First Edition
27 26 25 24 23 5 4 3 2 1

Published by
Gibbs Smith
P.O. Box 667
Layton, Utah 84041

1.800.835.4993 orders
www.gibbs-smith.com

Cover and interior designer: Ryan Thomann and Renee Bond
Art director: Ryan Thomann
Editor: Gleni Bartels
Production editor: Sue Collier
Production manager: Felix Gregorio
Printed and bound in China by Shenzhen Best Win Color Printing Co., Ltd.
Gibbs Smith books are printed on either recycled, 100% post-consumer waste,
FSC-certified papers or on paper produced from sustainable PEFC-certified
forest/controlled wood source. Learn more at www.pefc.org.

Library of Congress Control Number: 2023935351
ISBN: 978-1-4236-5527-5

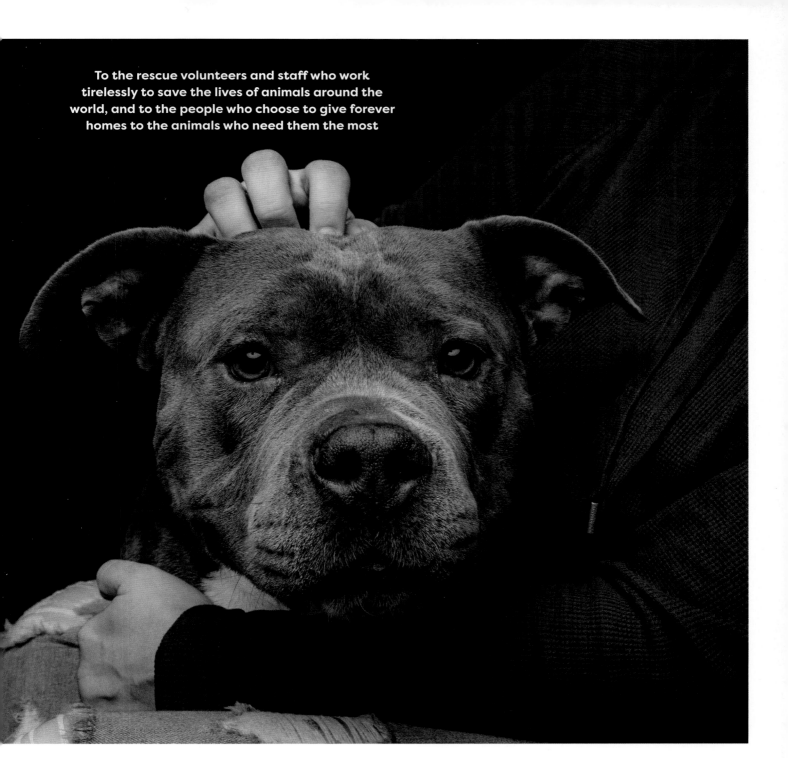

To the rescue volunteers and staff who work tirelessly to save the lives of animals around the world, and to the people who choose to give forever homes to the animals who need them the most

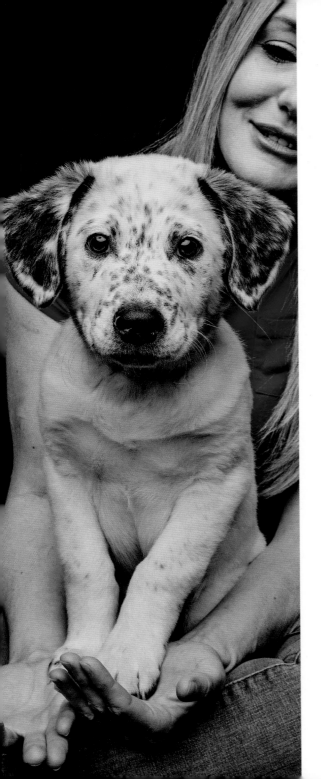

CONTENTS

FOREWORD

| BY DOUG TRATTNER, CLEVELAND-BASED AUTHOR, WRITER, AND EDITOR

When Tizzy (page 140) came into our lives, my wife, Kim, and I were not looking to adopt a new pet. We were still mourning the loss of our beloved rescue dogs who had passed away within weeks of each other. But these days, thanks to social media, you don't have to travel to an animal shelter to peruse their inventory. We "met" Tizzy virtually, from the comfort of our own living room, when she popped up on Greg Murray's Instagram account. As followers and fans of Greg's photography, it was only a matter of time before his picture of a goofy brindle bully showed up on our phone screens.

Tizzy's story starts predictably enough for a rescue: She and her sister, Tinker, survived as strays for months before landing at a high-kill dog shelter in southern Ohio. The big-hearted volunteers at Fido's Companion, a foster-based rescue in northeast Ohio, pulled Tizzy and Tinker, and then fostered and trained the dogs for months to increase their odds of finding their forever homes. Tinker *was* quickly adopted, but poor Tizzy moved from foster to foster for nine months. After seeing Greg's post, we arranged a visit with Fido's Companion and drove across town to meet her. She hopped right into Kim's lap for some attention, and it was clear that our next dog had found us.

By the time we met Tizzy, she was housebroken, crate-trained, and socialized. But that doesn't mean she came without challenges. Her high prey drive and desire to be dominant transformed her from the silly snuggle bug she is with us to a high-strung terrier whenever guests arrived. To address those issues, we worked with a professional dog trainer, who gave us the techniques and tools to deal with her fear and anxiety issues. Now when guests show up, Tizzy is calm, confident, and happy.

She joined the family almost four years ago, and we simply can't imagine life without her. We've had many rescue dogs over the years and loved them all, but Tizzy's giant heart and bigger personality outshine them all. Her goofy antics, piggie snorts, and boundless energy add joy and humor to every day. It breaks our hearts to think that she literally was days from being put to sleep.

Since we adopted her, Tizzy has gone swimming in Northern Michigan, dined al fresco in Maine, hiked in the Allegheny National Forest, and sunned her pink belly on the shores of

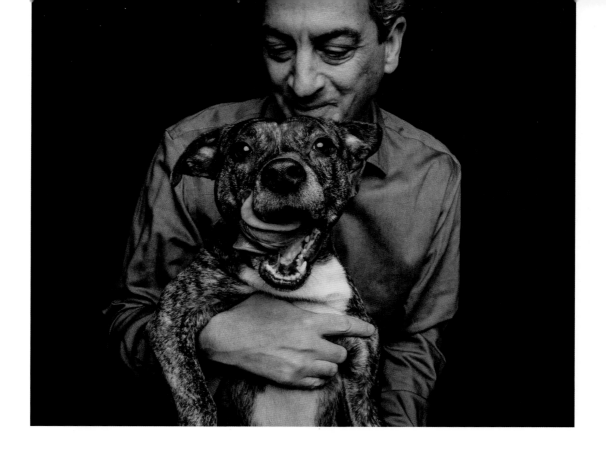

the Finger Lakes. Having her by our side while exploring, cooking dinner over the fire, or spending time inside during a rainstorm makes all our camping trips better.

Every now and then, one of the amazing people at Fido's Companion will see Tizzy living her best life on Instagram and leave a comment. We can only imagine how much it must mean to them to see how their patience and devotion to a rescue dog have changed her life. But we know too well that Tizzy is the exception. Despite being characteristically bright, loyal, affectionate, and gentle, bully breeds are unfairly discriminated against, thanks to decades of misrepresentation in the media. As a result, almost half of them don't make it out of shelters alive. In real life and on social media, we share our days and nights with Tizzy with the hope of changing those depressing odds of survival, if even by a tiny bit. Rescue dogs are no different from high-priced designer dogs—in both cases, you get out what you put in. But the satisfaction that comes from knowing you saved a life makes the experience that much more rewarding.

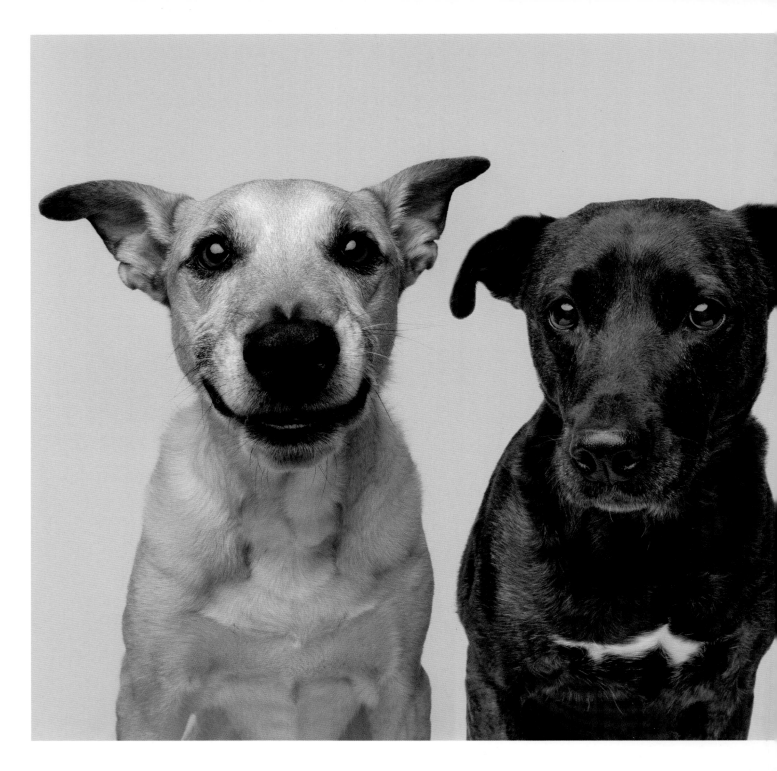

INTRODUCTION

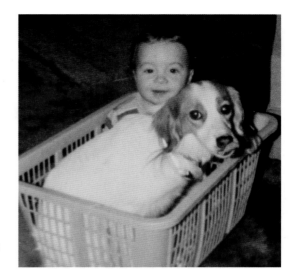

I was introduced to Muffit the rescue dog the day I came home from the hospital after entering this world in 1981. She had been adopted by my parents from the Cleveland Animal Protective League as a puppy two years before. I have vivid memories of spending time with Muffit as a child. We were best friends. As a baby I even enjoyed spending time with her in her crate and in laundry baskets.

I grew up around animals, which bred a lifelong affection for all kinds of critters, and I'm thankful to get to work with them daily. Besides Muffit, at one time or another, my family had fish, lizards, birds, guinea pigs, cats, rats, and more—and while I love all animals, regardless of where they came from, I do have a favorite kind: rescued. I don't think I fully appreciated the importance of animal rescues until I started volunteering as a photographer at the Cleveland Animal Protective League in 2012. There I encountered, through no fault of their own, dogs and cats who were just looking for love and a home. If you pay attention, it's easy to see the want and need for both in their eyes.

The feeling experienced when you rescue a dog or any other animal is priceless—not to mention the happiness, laughter, and love they bring into your life! And by making room for another animal to be rescued or fostered, you are potentially saving the lives of many. For those who have a rescue, be proud of yourself. Let others know. Brag about it. Share how amazing it is to rescue and save a life. Share how good your boy or girl is!

Above all, I wanted *Gotcha Day!* to capture the happiness, love, and connection shared between rescue dogs and their humans. Some dogs I photographed were adopted from shelters, some were foster fails, some were found on the side of the road, and some were a different story entirely, all of which you can read about in these pages. Some dogs have big personalities, and some of them are shy. They come in all shapes, sizes, breeds, and ages, but a rescued dog is my favorite dog.

◂◂ OUR RESCUE DOGS, LEO (LEFT) AND KENSIE (RIGHT)

Killian

DOES HE HAVE ANY NICKNAMES?
No, but he does get called handsome so often that he responds to it as if it's his name.

TELL US ABOUT GOTCHA DAY.
It only took me nine days to foster fail this big, sweet boy. At the time of adoption, he still wasn't okay with much human contact, but you could see he was trying. He watched our other goldens, Mojito and Julep, and tried to imitate their behaviors, which really solidified that he was meant to be ours. Our first meeting broke my heart. My husband had picked him up earlier that day from the rescue's partner vet and brought him home. We set up a space he could feel safe in as he acclimated, but when I arrived home from work, he was still cowering in a corner and shaking. He had the saddest eyes. He was super interested in the girls but very unsure of us adults.

WHAT ARE HIS FAVORITE THINGS TO DO?
Snuggling on the couch, eating ice cream, and visiting all the friends he's made as a therapy dog.

DOES HE HAVE ANY SILLY QUIRKS?
Killian is obsessed with clothing. He has his own closet full of clothes (that he has now outgrown). He will beg at the door and paw at the outfit he wants. If it's below forty degrees, he will absolutely refuse to go outside without a coat on over his shirt. "Old man" clothing, like cardigans, is his favorite. If we are out shopping and Killian sees a shirt, he'll try to put his head in it and try it on right there.

WHAT DOES HE MEAN TO YOU?
Killian is the epitome of resilience. He was used for breeding at an Amish puppy mill and had no socialization or understanding of how to be a dog. To see him transform from the scared shell of an animal he was into the happiest, most loving boy has been amazing.

ANYTHING ELSE WE SHOULD KNOW?
He overcame his immense fear of humans to become a registered therapy dog with the Alliance of Therapy Dogs. He completed his testing in April 2022 and has now visited assisted living homes, memory care centers, and even a school. Killian is all looks, no brains. He often has no clue what's going on, but he's sure excited to be there doing whatever it is.

—*Kim*

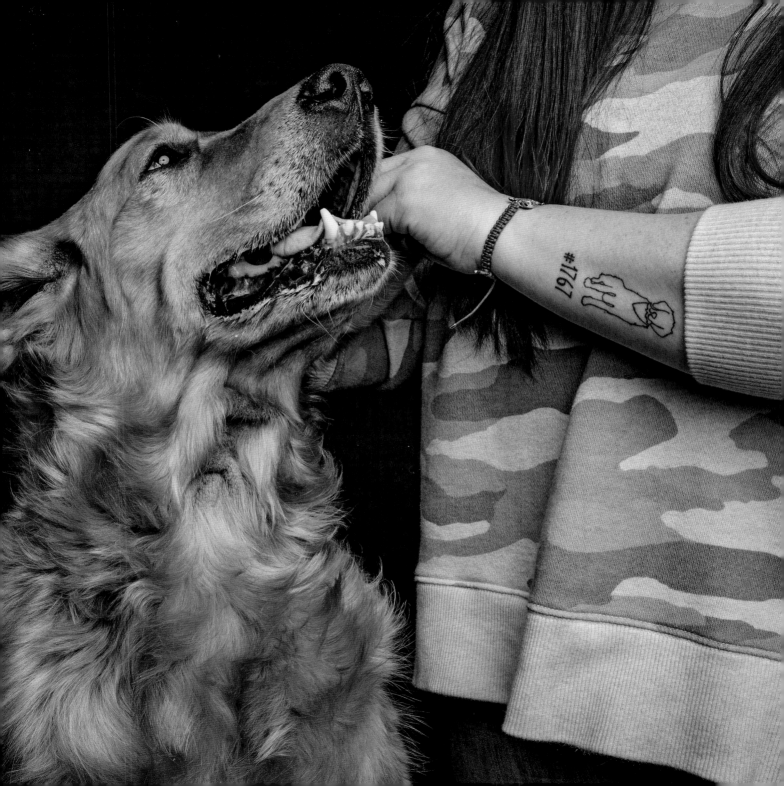

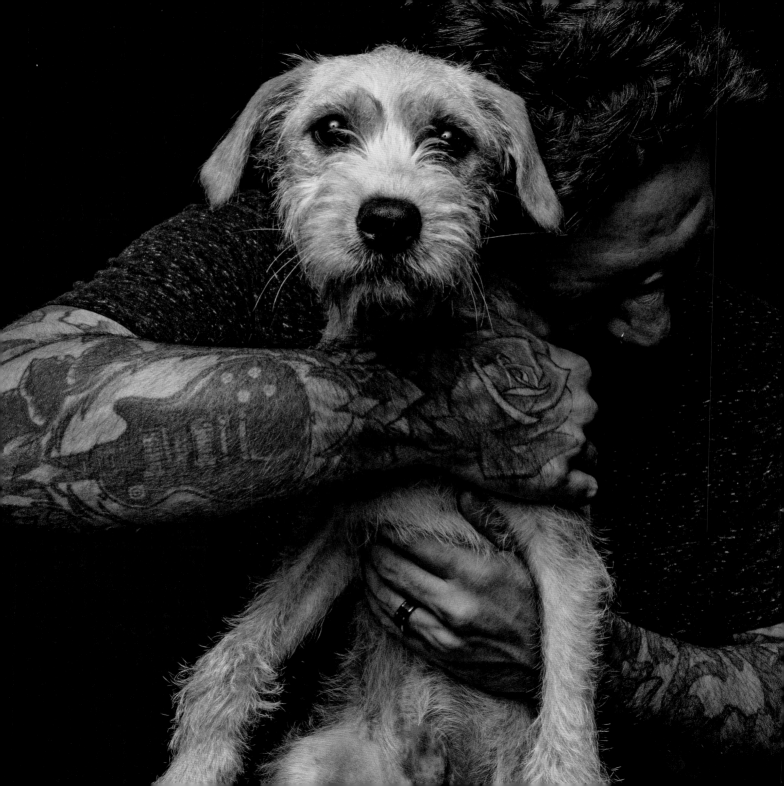

Waffles

| MINI LABRADOODLE MIX, 9 MONTHS OLD

DOES HE HAVE ANY NICKNAMES?
Fast Boi

TELL US ABOUT GOTCHA DAY.
We saw Waffles's picture while on vacation with friends in Savannah, Georgia. We had been looking for a new dog for a few months after losing our last one but were planning on getting a Rottweiler, Dutch shepherd, or another Malinois that was more "on brand" for us. After joking about it all weekend with our friends, we brought him home a few days after we got back into town.

WHAT ARE HIS FAVORITE THINGS TO DO?
Playing with his older dog siblings, chewing sticks, going to work to help the new trainees at Miracle K9 Training, and annoying the cat.

WHAT DOES HE MEAN TO YOU?
Having a dog gives me a much-needed break from all of the seriousness and stress of life. They are simple creatures with minimal wants and needs aside from living in the moment—something we can all learn from.

ANYTHING ELSE WE SHOULD KNOW?
As a dog trainer, I am expected to maintain the standard of what the average owner should do to have a well-behaved dog. For his first three days at home, Waffles screamed in the crate all night, so in the bed with us he went. (We've since worked on those crate issues.) We're all human, even us professionals.

—David

Grimly Fiendish

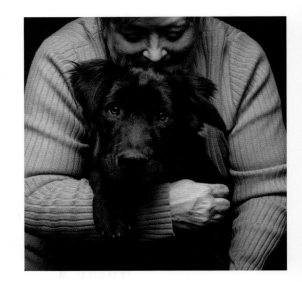

| GERMAN SHEPHERD
| MIX, 1 YEAR OLD

DOES HE HAVE ANY NICKNAMES?
Grim Reaper, Grimbly Bimbly, Grumbly

TELL US ABOUT GOTCHA DAY.
I have always rescued and loved pit bulls, but there was something about this chunky, fuzzy, big black puppy face that completely stole my heart. I didn't even try to set up a meet and greet; I filled out the adoption form before I met him. It truly was love at first sight.

WHAT ARE HIS FAVORITE THINGS TO DO?
Playing with other dogs, chasing tennis balls, swimming, and sleeping in holes he's dug himself.

DOES HE HAVE ANY SILLY QUIRKS?
He talks. A lot. And he's loud. And I don't mean barking. He rarely barks. He also does funny things with the position of his ears: Sometimes one is up and one is down, sometimes both are straight up, and sometimes—rarely—both are down. No idea if it's related to mood since it seems pretty random, but it's funny.

WHAT DOES HE MEAN TO YOU?
He owns me, body and soul.

ANYTHING ELSE WE SHOULD KNOW?
All three of the other dogs in the house are in love with Grim, even Whisper, who honestly hates all animals outside of her "family" and barely tolerates the ones in it. He wakes her up every morning by trying to put her huge head in his big mouth and "talks" to her. And I swear, she laughs at him!

—Sandy

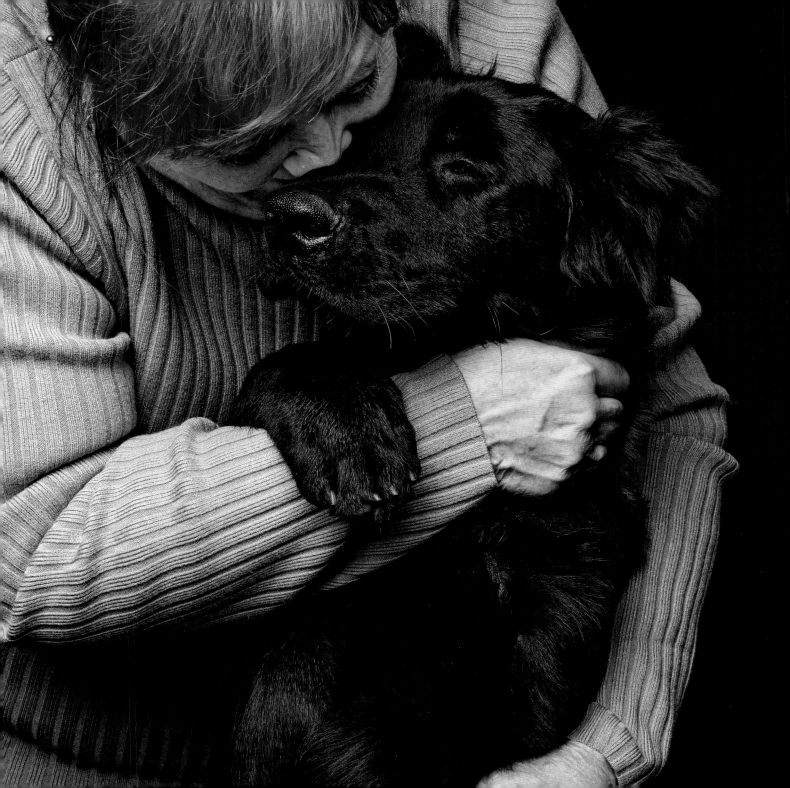

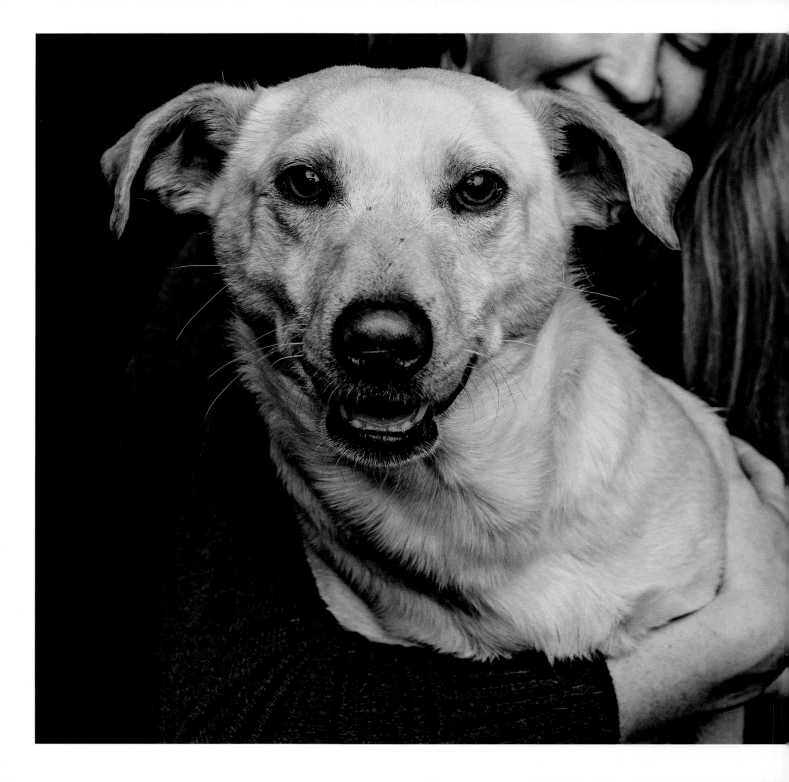

Jet

DOES HE HAVE ANY NICKNAMES?
Jetty Poo and Jet Jet

TELL US ABOUT GOTCHA DAY.
We wanted to adopt Jet because his personality fit so well with our other dog. They are opposites that balance each other out. Jet is energetic and cuddly, and Bowie is calm and prefers to be left alone most of the time.

WHAT ARE HIS FAVORITE THINGS TO DO?
Cuddling (especially with Mom), chewing on dental bones, and stealing toys from his big brother, Bowie.

DOES HE HAVE ANY SILLY QUIRKS?
He jumps straight into the air like he's riding a pogo stick to see what's on the kitchen counter. He also snores very loudly.

WHAT DOES HE MEAN TO YOU?
Jet means everything to us. He has been the perfect addition to our little family, and we couldn't imagine not having him in our lives. I jokingly call him my soulmate, but I truly believe he was meant to be our dog.

ANYTHING ELSE WE SHOULD KNOW?
When we adopted Jet, we assumed he was a corgi-lab mix due to his coloring, body shape, and docked tail. We did a DNA test and discovered that his father was a purebred Chihuahua and his mom was a lab mix. We were shocked because we had all taken bets on what breeds he is, and we were all wrong!

—Megan

Momma

MINI SCHNAUZER, MINI POODLE, ESKIMO, AND
POMERANIAN MIX, 18 YEARS OLD

DOES SHE HAVE ANY NICKNAMES?
Mamacita, Old Lady, Yes Ma'am

TELL US ABOUT GOTCHA DAY.
Between November 2020 and January 2021, I lost three of my dogs—two to cancer
and one to kidney disease. I was devastated. My surviving Chihuahua was beside
himself since he had never been without another dog. We grieved for about a month
before we saw a post about Momma needing a new foster, and we jumped at the
chance. The first night, she walked into the house like she had been there a million
times. She settled in and became my Chihuahua's new security blanket. I couldn't
let her go after that.

WHAT ARE HER FAVORITE THINGS TO DO?
Momma loves watching out the window and barking at passersby. She loves
meandering on walks and smelling everything. She likes to sleep on my bed and has
a special blanket just for that.

DOES SHE HAVE ANY SILLY QUIRKS?
She makes a litany of sounds to express herself in addition to her barking. She has
loud yawns and specific noises when she wants to be let out or picked up or for
attention. She also jumps and hops excitedly for meals and walks.

Momma has limited vision. Whenever she wakes up from a nap, she walks around
the house looking for me. Usually, I'm very nearby, but she always makes her rounds.

WHAT DOES SHE MEAN TO YOU?
She is a very special dog. Resilient. She was originally brought in as a hospice case,
but she has far exceeded predictions. She was underweight and almost hairless, and
buckshot was found on a pre-op X-ray. She has survived it all and is still as sweet as
can be.

—Julianne

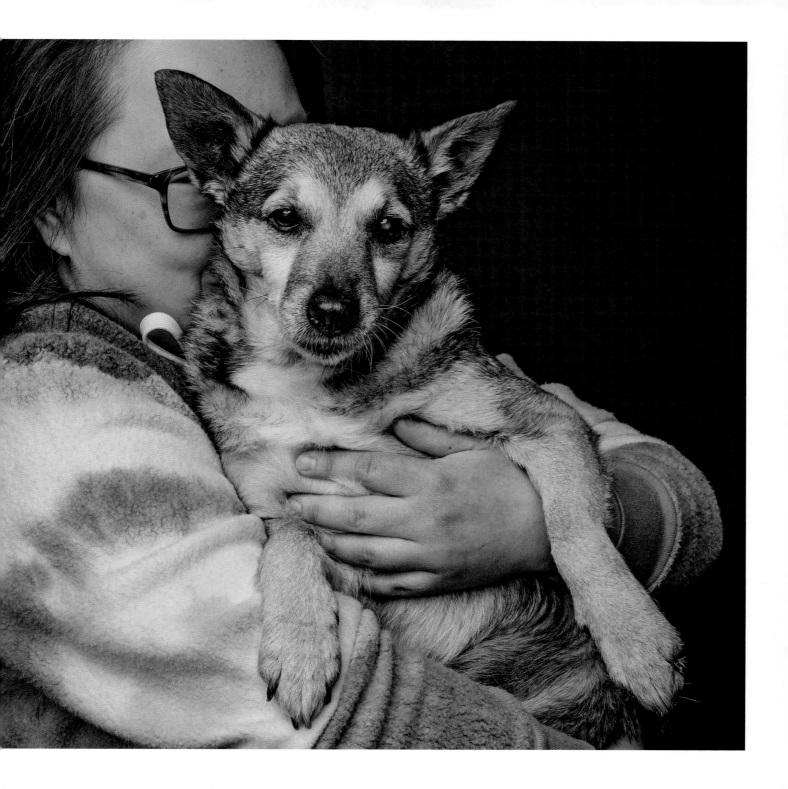

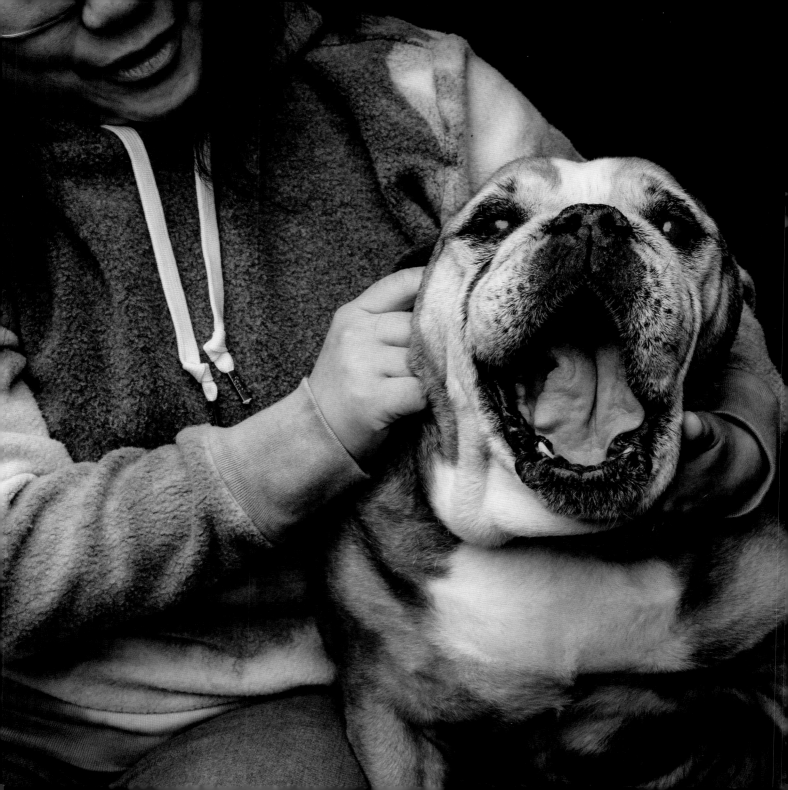

Gertie

| ENGLISH BULLDOG, 13 YEARS OLD

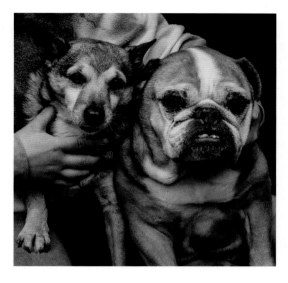

DOES SHE HAVE ANY NICKNAMES?
Gert, Gogurt, My Gerts

TELL US ABOUT GOTCHA DAY.
She was a foster fail. When I got her, she was a complete mess. She had skin, eye, and ear infections and was underweight. We went through many months of trying to get her better. She had an open and draining abscess on the side of her head from an untreated ear infection. Eventually, both of her ear canals were removed to get rid of the chronic infections. Slowly we bonded, and she came out of her shell, and I couldn't let go of her after that. She is deaf and visually impaired but still manages to find her way around, and her nose tells her whenever food is available.

WHAT ARE HER FAVORITE THINGS TO DO?
Sleeping in her bed with her own personal fan. Getting butt scratches and belly rubs.

DOES SHE HAVE ANY SILLY QUIRKS?
She stands on her back feet with her arms on the dish rack, trying to get a better view of me making her meals.

WHAT DOES SHE MEAN TO YOU?
She's the best. She makes my life happier and more fulfilling. I'm a doctor, and people assume I'm a vet because of all the animals I have. But I just seem to get along much better with dogs than with people. There is something special about the human-dog bond that can't be replicated in human relationships.

ANYTHING ELSE WE SHOULD KNOW?
She is a sweet old gal, and even with what many would assume to be handicaps, she is thriving in her golden years.

—Julianne

Roger

YORKSHIRE TERRIER, 7 YEARS OLD

DOES HE HAVE ANY NICKNAMES?
Rogey, Rogey Man

TELL US ABOUT GOTCHA DAY.
I have a passion for rescuing Yorkies from puppy mills. A lot of times, these dogs have trust issues and are very fearful of humans. Roger was the total opposite when I first met him. He ran right up to me and was the happiest dog I had ever seen. It's inspiring to see how happy Roger is now despite the negative experiences he had in his past. He loves people and will happily greet strangers. And most important, he loves his family.

WHAT ARE HIS FAVORITE THINGS TO DO?
Roger enjoys the freedom of running around and exploring the backyard. He also likes to wrestle with his brother, Lenny.

DOES HE HAVE ANY SILLY QUIRKS?
Roger lost most of his teeth, so his tongue sticks out, which is absolutely adorable.

When he's tired, he likes to put himself to bed, which consists of him sitting at the bottom of my bed and waiting for me to pick him up and place him in there with me.

WHAT DOES HE MEAN TO YOU?
Roger was a breeding dog in a puppy mill and was rescued at six years old. I want to make sure the second half of his life is the total opposite of his puppy mill experience. He truly lives a luxurious life now! He is the sweetest and happiest dog, and when he cuddles up with me at night, it melts my heart.

ANYTHING ELSE WE SHOULD KNOW?
We welcomed a baby girl earlier this year and weren't sure how Roger would react. But he loves his baby sister and is very sweet and protective of her. Every morning he greets her with kisses, and he loves to snuggle next to her during nap time.

—Erin

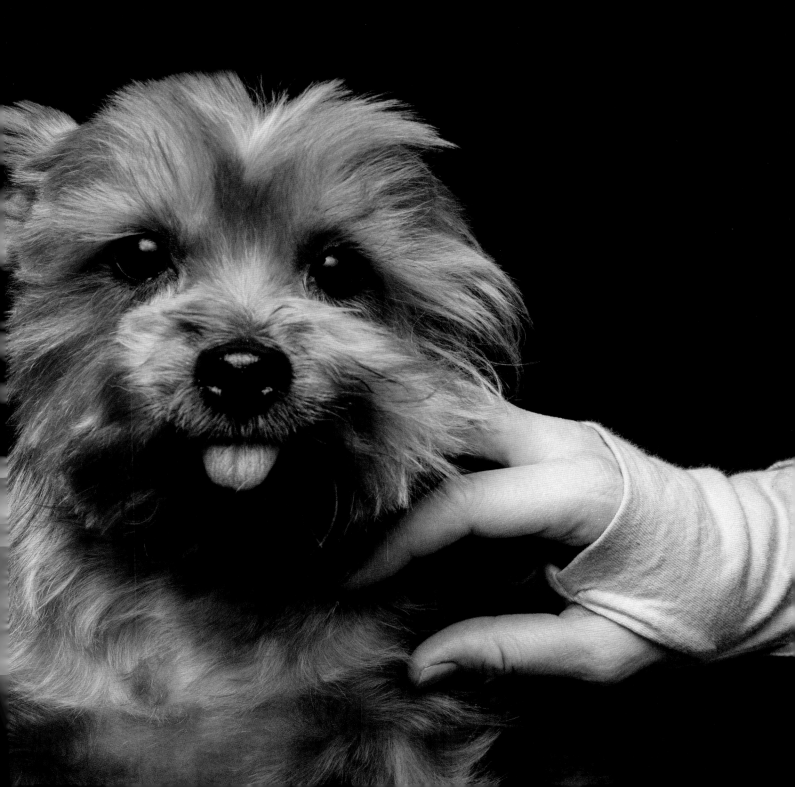

Peaches

| PIT BULL MIX, 1.5 YEARS OLD

DOES SHE HAVE ANY NICKNAMES?
Peachy Girl, Peachy, Peach

TELL US ABOUT GOTCHA DAY.
I picked up Peaches from the Cleveland City Kennel, and she was only about five months old. She was a complete mess and super skinny with infections in both of her eyes, yet she was so excited to see me. I started fostering in April 2021, and by the end of May, the rescue decided to send her to their trainer to work through her behavior issues. Before she was set to go, I noticed she had a cherry eye (an inflamed eyelid), and she had surgery. The recovery was rough, and she completely shut down at the trainer's and would shake in the corner while the other dogs played—totally not the Peaches we all knew! I immediately told the rescue I would take her back to see how she'd do with us. And just like that, she was back to her normal self.

She had to have another surgery to have a cyst removed, and we learned that her cherry eye had relapsed. After she recovered and was cleared by the vet, we realized that Peaches was meant to be with our family. She had improved while in our home, got along with our other dog and cat, and no longer had any behavior issues. So after seven months of fostering, with almost zero interest from other adopters, we decided she was here to stay!

WHAT ARE HER FAVORITE THINGS TO DO?
She *loves* to eat. She is super food motivated and will try anything you give her. She loves to play, but she's also a cuddle bug.

DOES SHE HAVE ANY SILLY QUIRKS?
She loves to curl up into any small crevice she can find, specifically by Mom, Dad, or her fur brother. She will also lay in the weirdest positions, stretching out half on the couch and half on the ottoman (with a huge gap in between).

continued ▶▶

Peaches means a lot to our family for many reasons. She was found as a stray on the streets of Cleveland, and we have no idea what her life was like before then. When we first started fostering, she had a few behavior issues that we had to work through, but she has come so far since then. She is incredibly smart (yet stubborn) and learns things quickly. She's done a complete one-eighty and has taught us that with love, patience, and a little extra time, you can overcome any obstacles life has thrown at you.

ANYTHING ELSE WE SHOULD KNOW?

When the rescue reached out to ask if I could foster a puppy, they told me they needed a name for her. I am obsessed with Justin Bieber, and his song "Peaches" was popular at the time, so I jokingly said to name her Peaches, and they did!

—Alexandria

"She's done a complete one-eighty and has taught us that with love, patience, and a little extra time, you can overcome any obstacles life has thrown at you."

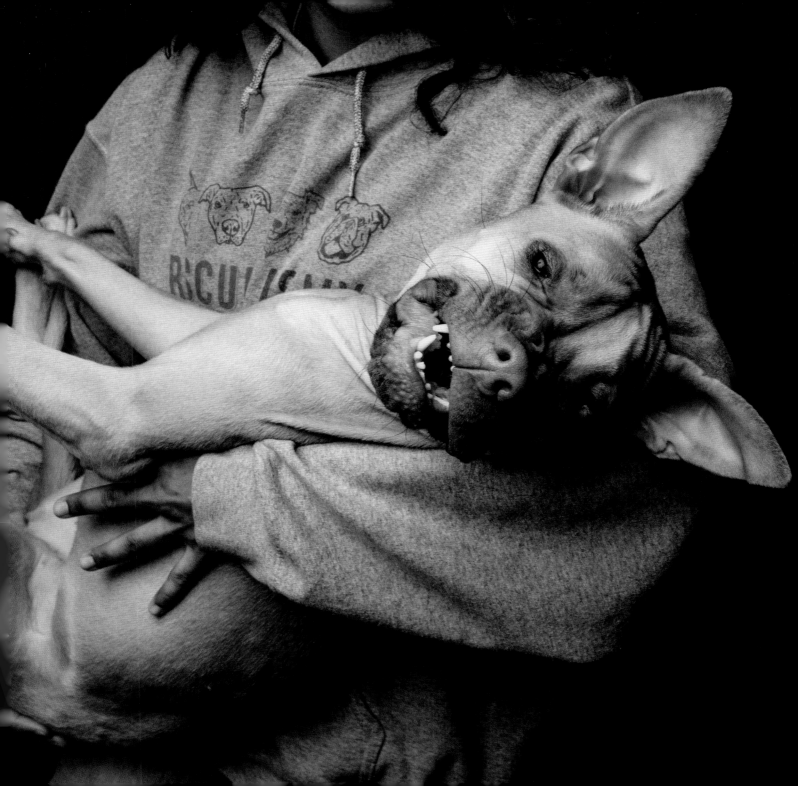

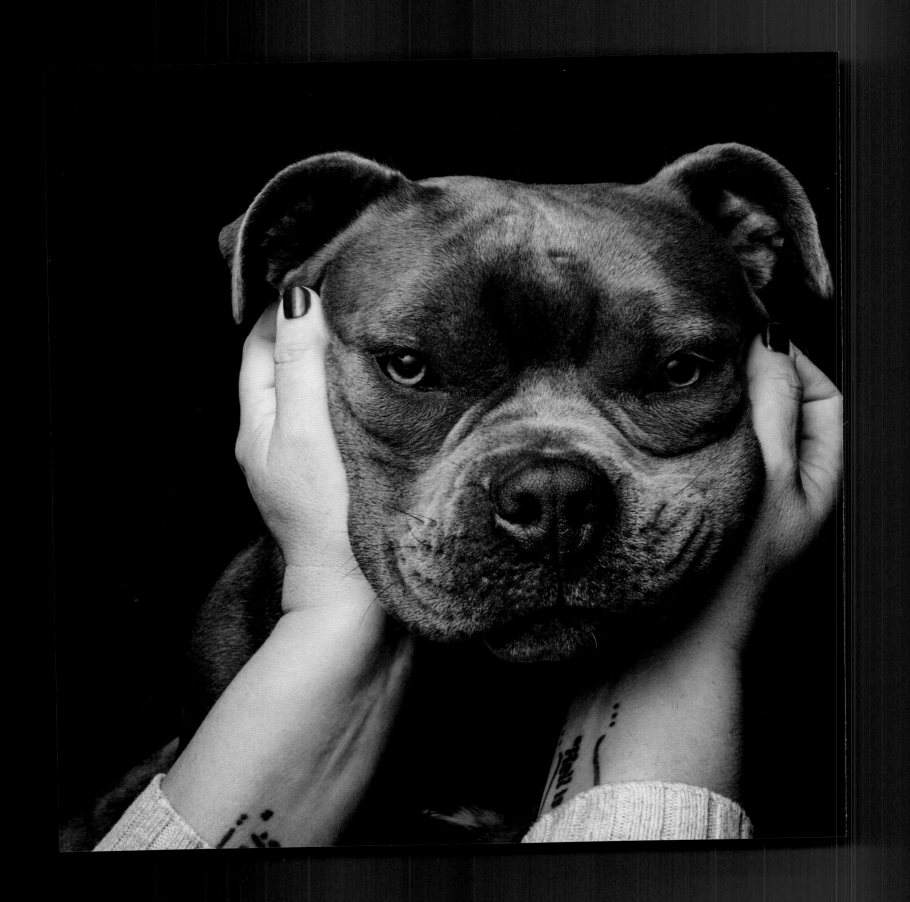

Edith Ann

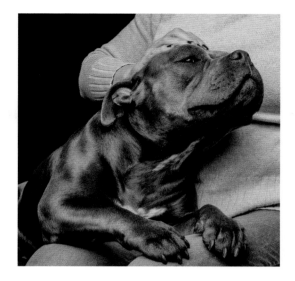

| AMERICAN STAFFORDSHIRE
TERRIER AND ENGLISH
BULLDOG MIX, 2 YEARS OLD

DOES SHE HAVE ANY NICKNAMES?
Edie, My Little Gremlin

TELL US ABOUT GOTCHA DAY.
We first met in a kennel at the Cleveland APL.
She was mostly bald on her back from dermatitis and smelled yeasty and gross
after being seized from a neglectful situation. But she wagged her tail with her
whole butt, and I couldn't resist petting her. She crawled into my lap, and I knew
immediately I'd be taking her home.

WHAT ARE HER FAVORITE THINGS TO DO?
Edie loves being social, whether it be with people or dogs. She will seek out new
humans—especially kids—to say hello when given the opportunity. She loves taking
walks around the neighborhood and playing in the backyard with her best friend,
my other dog, Rupert.

DOES SHE HAVE ANY SILLY QUIRKS?
She only barks when she wants attention. The room will be quiet, and suddenly, she
will jump up, bark loudly, then stomp her feet until Rupert or I engage her in play. If
neither of us comes forward, she throws herself on the floor in a huff. It is hysterical.

WHAT DOES SHE MEAN TO YOU?
Edie is the embodiment of sweetness and what bully breeds are capable of. She
is kind and gentle and sets everyone at ease when she meets them. I had no idea
how amazing she would be when I adopted her—I just thought she was the cutest
pup ever.

—Katherine

Trinket

DOES SHE HAVE ANY NICKNAMES?
Trinket Stinket, Trinks, Bill, Trinky

TELL US ABOUT GOTCHA DAY.
What stood out to us first was her name, Trinket. Her humans have a mild addiction to collecting trinkets—so we thought Trinket must be a match made in heaven for our family. I had adopted my other dog, Penny, about ten years ago, and she is quite selective about which dogs she will socialize with. Multiple Breed Rescue had an adoption fair, and they were holding Trinket for us to meet. Penny and Trinket walked right up to each other, did a quick "What's up?" sniff, and then started walking along together. We knew it was game over, and Trinket would be joining our pack.

WHAT ARE HER FAVORITE THINGS TO DO?
Trinket loves wrestling Penny, biting her toenails, going for walks, getting the zoomies in the backyard, hitting tricks on the half-pipe (aka the sectional couch in the living room), napping, and snuggling with us.

DOES SHE HAVE ANY SILLY QUIRKS?
She bites her toenails, and she barks relentlessly at the neighbor's patio umbrella—a clear threat!

WHAT DOES SHE MEAN TO YOU?
Trinket means so much to our little family. She has taught us to practice patience and that trust is earned over time. Trinket had a rough start to her life and is not very trusting of humans. Her big sister, Penny, showed her the ropes on how to be a dog, and the two have become best friends. We cannot remember what life was like before Trinket entered our home and stole our hearts.

ANYTHING ELSE WE SHOULD KNOW?
Fun fact—we almost lost Trinket the first day we had her. We drove home with her, and when we got out of the car, somehow the leash fell to the ground. She quickly took off down the driveway and was speeding down our street. Miraculously no cars were coming. We didn't think she would come to us if we called her, since she hadn't known us for more than thirty minutes. So we stupidly ran after her. After an incredibly fast chase and many failed attempts to grab her leash, we decided to stop and try to call her one last time. She quickly stopped when we stopped, walked over to us, and let us pick her up.

—Chelsea

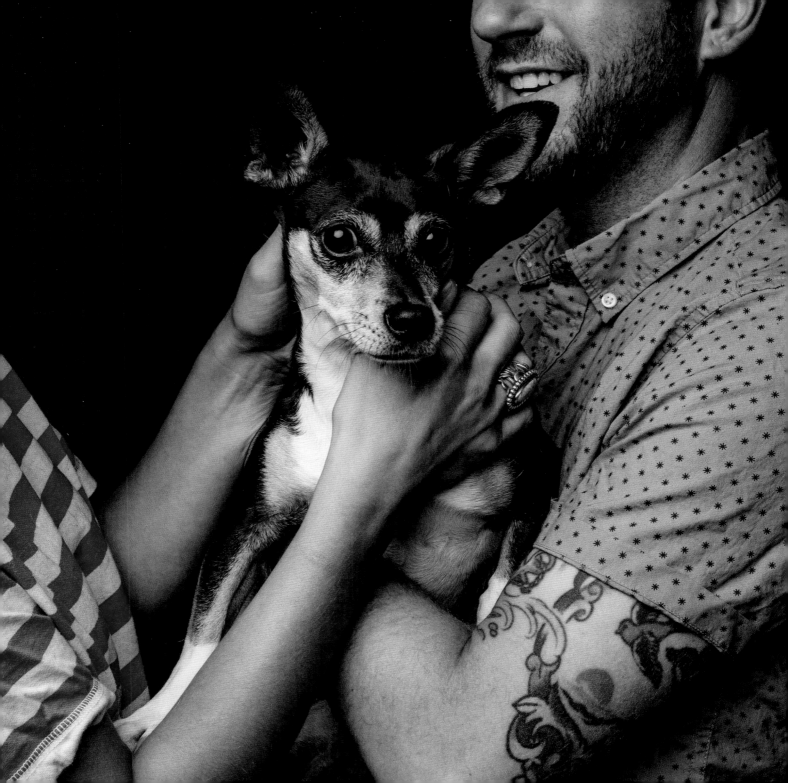

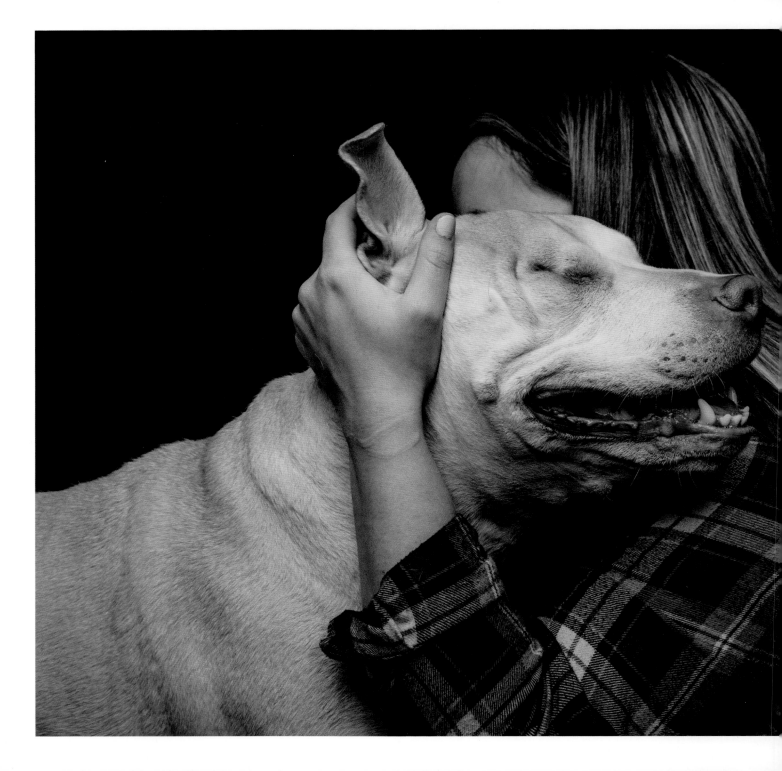

Selena

| PIT BULL, 6 YEARS OLD

DOES SHE HAVE ANY NICKNAMES?

Selly is the nickname we use the most. Otherwise, she most commonly gets called Sel, Bub, Bubs, Bubby, and Boofy. She responds to all of these names, too!

TELL US ABOUT GOTCHA DAY.

When I first saw her on social media, it was about four months after my last dog, who was also blind, had passed. When I saw that she was at our local shelter, I knew I needed her to fill the void in my heart and home. I sent in the application, met her within a few days, and waited a few more for her stitches to come out so I could bring her home. During our first meeting, I could tell just how sweet she was. She was very attached to the volunteer at the shelter and didn't want much to do with me at first, but I still wanted to bring her home and give her the best life—which I'm still striving to do every day.

WHAT ARE HER FAVORITE THINGS TO DO?

Selly loves to run around with her tennis ball, play tug, and suckle on her blankets. She is also a master napper.

DOES SHE HAVE ANY SILLY QUIRKS?

Selly *loves* blankets so much that she'll try to be sneaky and steal whatever blanket someone is using, especially if it's one she isn't usually allowed to have. She will also go to the basement where her spare blankets are, find one she wants, and take it all the way upstairs to her bed—all while being 100 percent blind.

WHAT DOES SHE MEAN TO YOU?

Selly means everything to me. I often call her my soul dog or the love of my life because I really believe she is. She makes the bad days so much better, and she truly fills my heart with overwhelming love and joy. I cannot imagine my life without her.

continued ▶▶

Some might think Selly is spoiled by the number of colorful bandanas she has, the number of toys she gets, or how I've given up many of my own blankets for her. But honestly, I feel that she deserves all of those things and more for the life that she was dealt before she met me. Selly is the first dog that is my own and the first dog that I've rescued. And she is the first pit bull in my family; I'll never choose any other dog breed again. She has changed everything in my life for the better. And because of her, I am an advocate for rescues, disabled dogs, and pit bulls. I wouldn't change anything.

ANYTHING ELSE WE SHOULD KNOW?
She loves her tennis balls so much that they'll break, and then I have to buy new ones for her. I ordered a pack online and left them on my dresser, thinking I'd give one to her in the morning. I went to shower, and when I came back, the whole pack was laying next to her on my bed. She could somehow smell the tennis balls in the packaging on my dresser, so she jumped up and grabbed them and put them on the bed next to her. I was in disbelief. So, obviously, I let her have one that night instead of waiting for the next morning.

—Halle

"She makes the bad days so much better,
and she truly fills my heart
with overwhelming love and joy.
I cannot imagine my life without her."

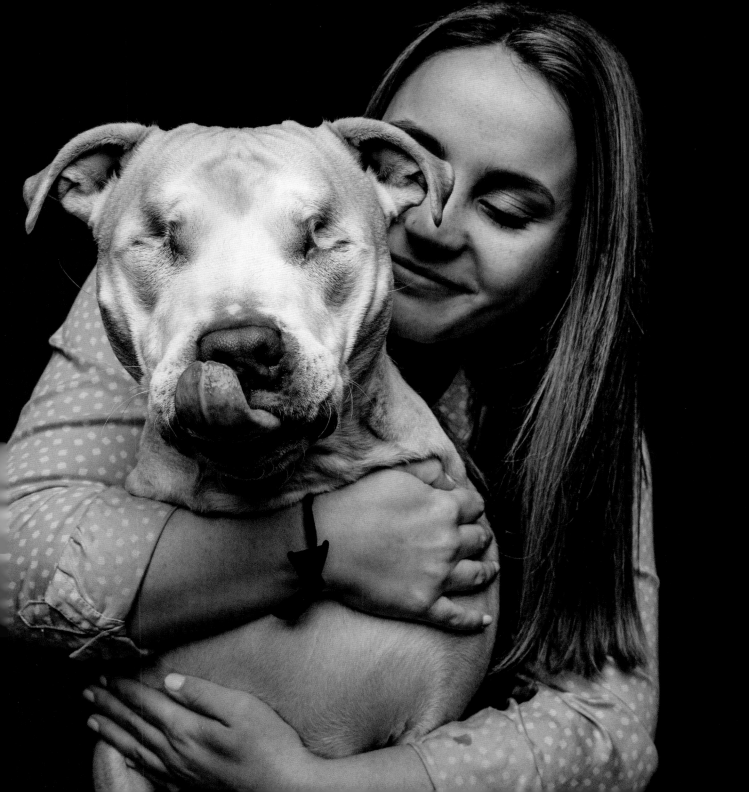

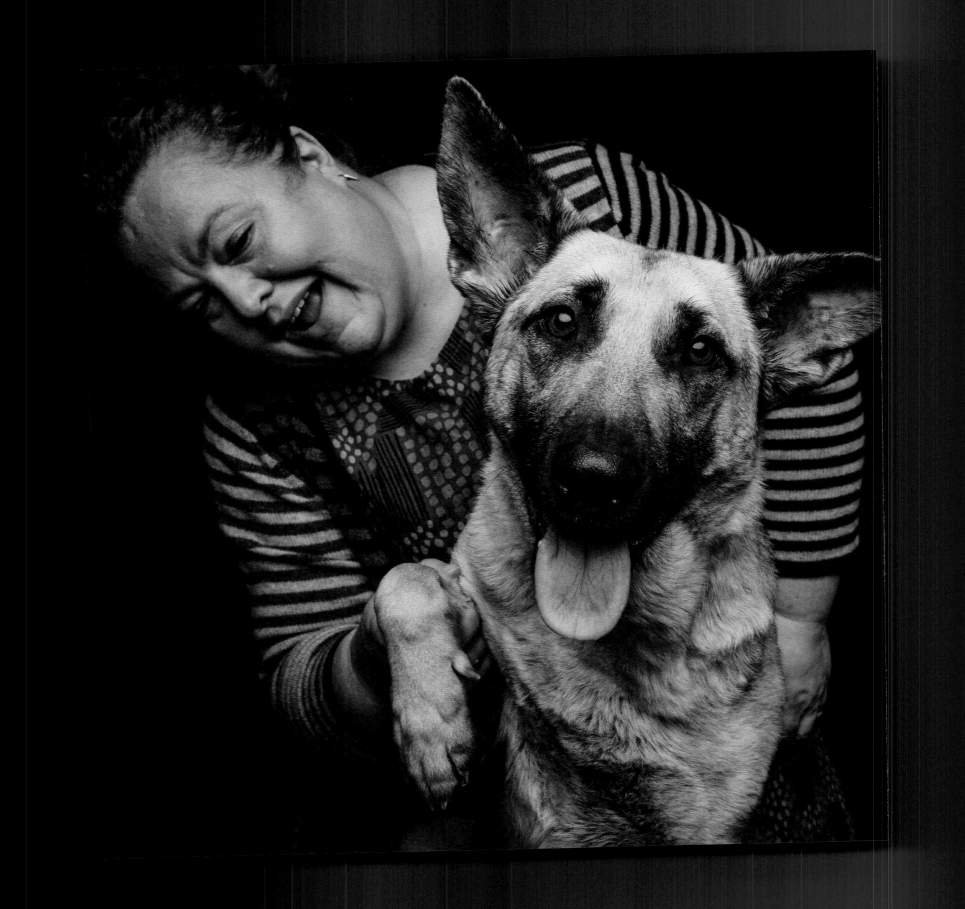

Ursula

| GERMAN SHEPHERD, 2.5 YEARS OLD

DOES SHE HAVE ANY NICKNAMES?
Porpy, Big Kitty, Madam, Orsi, Uschi

TELL US ABOUT GOTCHA DAY.
I had wanted another dog after our last one died, when I happened upon Ursula's listing. Ursula's original family was moving out of state, and we are so grateful to the rescue that put us together. My first thought was that she looked so much like my childhood German shepherd. She was really scared at first, and it was next to impossible to get her into the car. She got carsick a few times. But now she's a pro at going everywhere.

WHAT ARE HER FAVORITE THINGS TO DO?
Ursula *loves* the dog beach at Edgewater on Lake Erie! She isn't too fond of toys in general, but she adores chasing other dogs and being chased in return. We often go for playdates at her boyfriend Apollo's house. He's also a German shepherd, and they play very sheppie-specific games with each other. Sometimes Ursula gets sad when other dogs don't know how to play Apollo's super fun games, which include crashing into each other in midair at top speed.

DOES SHE HAVE ANY SILLY QUIRKS?
She loves blueberries, smoked almonds, and Goldfish crackers. She would scale Mount Everest for the latter two (which she gets only on rare occasions).

WHAT DOES SHE MEAN TO YOU?
Ursula has been a significant bridge between me and my depression. She not only gets me out of bed in the morning, but she gets me out of the house. It has been incredibly good for both of us. I don't think her first family really took her anywhere or socialized her, so our first half a year together has been us against the world, 24-7. I can count on one hand the number of times we've been apart. She goes everywhere with me. She's the best.

ANYTHING ELSE WE SHOULD KNOW?
She loves our cats. She was raised alongside a cat, so she knows how they roll, but our cats are considerably older, and it has been an adjustment period for everyone. I knew we'd finally made it when our Siamese willingly slept in bed all night with Ursula and me.

—Shannon

Luna

| GREAT PYRENEES AND ANATOLIAN SHEPHERD MIX, 1 YEAR OLD

DOES SHE HAVE ANY NICKNAMES?
Her full name is Luna Persephone Lovegood. Her nicknames are Luna, LuLu, Lu, Lunacris.

TELL US ABOUT GOTCHA DAY.
Luna was born in Texas, transported to Illinois for us to pick her up, and driven to her home in Ohio!

WHAT ARE HER FAVORITE THINGS TO DO?
Luna loves to be outside. Her joints make her a bit wonky when walking and running, but she patrols the backyard and sits in various spots and observes. She sure is fond of digging up the garden as well.

DOES SHE HAVE ANY SILLY QUIRKS?
Luna has a famous flop she does with her body when she wants to snuggle. She will then bury her nose into a part of your body and just breathe deeply like she's snoring.

WHAT DOES SHE MEAN TO YOU?
We are her people just as much as she's our dog. It's a mutually beneficial relationship of serotonin exchanges.

—*Beth*

"We are her people just as much as she's our dog."

Astrid

| PIT BULL, 8 YEARS OLD

DOES SHE HAVE ANY NICKNAMES?
She has so many nicknames. The most common are Bean, Vanilla Bean, Beanie Baby, Miss Bean, Princess Astrid, and Stinky Butt.

TELL US ABOUT GOTCHA DAY.
When we met Astrid she was timid and shaking, but immediately she licked my husband Jared's face and accepted treats. It was obvious she was a gentle soul who'd had a rough life but wanted to be a part of a family. She was seized from a breeding/hoarding situation and had lived her whole life in a kennel having puppies. Her resilience and continued desire to interact with humans are remarkable to me, given what she went through there. We loved her immediately, and she came home with us that day. We all had a lot of learning and adjusting to do when we got home, but we figured it out together, and her personality has blossomed as her confidence grows.

WHAT ARE HER FAVORITE THINGS TO DO?
Astrid loves going on walks, snuggling her stuffed animals, and eating snacks. She's a chill gal who knows the value of a comfy couch and a long nap.

DOES SHE HAVE ANY SILLY QUIRKS?
She loves to sit on the couch like a person: on her butt with her legs straight out in front of her. She adores taking gifts out of gift bags. And she loves to wear a bandana. She has many options depending on the day and will excitedly come running when it's time to put one on.

WHAT DOES SHE MEAN TO YOU?
She is our greatest joy and the best decision we ever made. She has taught us so much about love and understanding and responsibility. We didn't realize how

continued ▶▶

incomplete our family was until she arrived in our home and took her spot, which happens to be directly between us in bed, snoring and kicking wildly. The love I feel for her is unconditional. I truly consider her to be my best friend.

ANYTHING ELSE WE SHOULD KNOW?

One of the greatest things about Astrid is how tough she is in the face of adversity. Not only was her prior life terrible, but her troubles have not ended with her happy new home. She was diagnosed with cancer in early 2022, but following surgery is making a great recovery and is now in remission. She faces every challenge with her famous smile. Astrid still asks to go on walks even when she's sick and in pain. Nothing can stop this little girl from taking on the world.

—Carson

"She is our greatest joy and the best decision we ever made. She has taught us so much about love and understanding and responsibility."

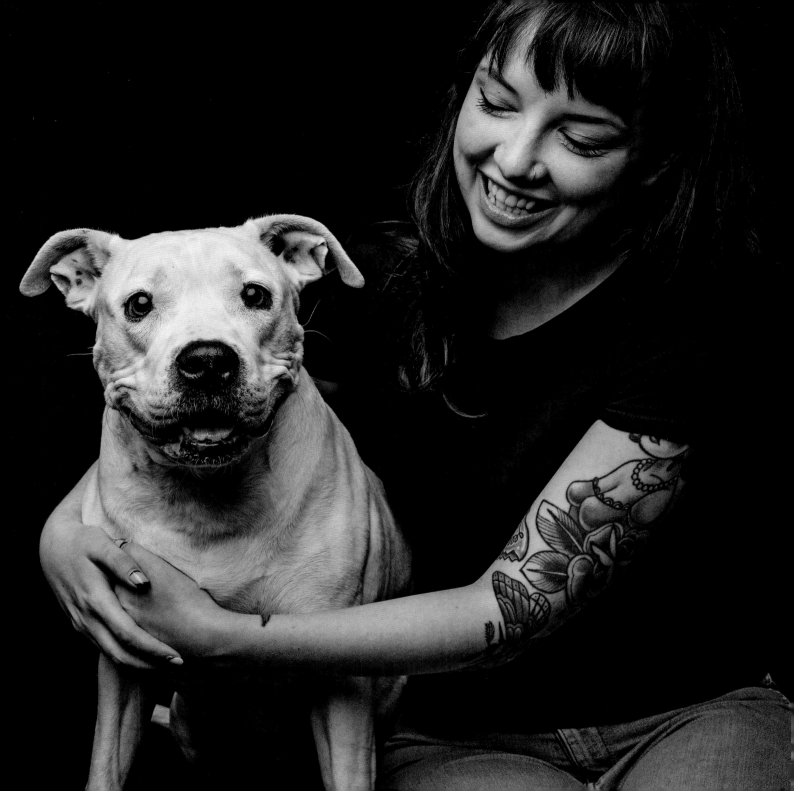

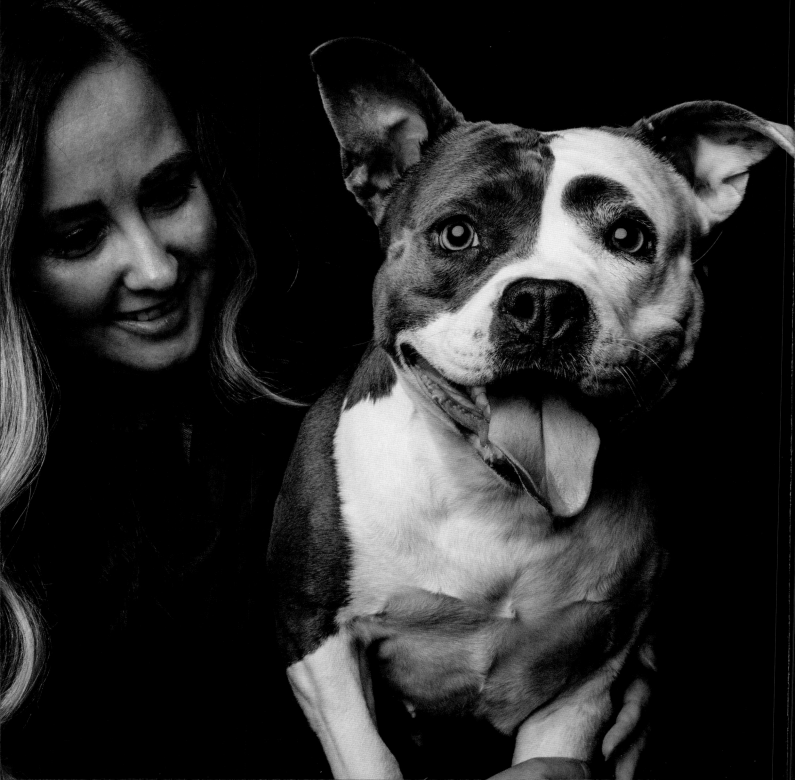

Nugget

AMERICAN STAFFORDSHIRE TERRIER

DOES SHE HAVE ANY NICKNAMES?
The Flying Bowling Ball

TELL US ABOUT GOTCHA DAY.
I saw the photo Greg took for City Dogs on
Facebook. At our first meeting, she looked very
defeated, shut down, and shy, but she did sit
with us and wanted scratches as she warmed
up. You could see in her eyes that she had been through a lot.

WHAT ARE HER FAVORITE THINGS TO DO?
Dock diving and snuggling

DOES SHE HAVE ANY SILLY QUIRKS?
Nugget has her own language that consists of a unique combination of purring and
grunts. She makes funny noises when she is happy or awaiting a treat.

WHAT DOES SHE MEAN TO YOU?
This dog means everything to us. We feel as if she has been a part of our family
forever, even though she has been with us for less than a year. She is the most loving
dog sister and "Velcro" dog.

ANYTHING ELSE WE SHOULD KNOW?
Nugget is obsessed with water! She began training and competing in dock diving
this summer. She screams and shrieks at the sight of the pool and drags us to the
dock. We are so proud of how she improves each time she goes to training, and we're
happy she has a "sport" she enjoys so much.

—Mary

Lloyd

| BREED UNKNOWN, 1.5 YEARS OLD

DOES HE HAVE ANY NICKNAMES?
They all stem from Yittle Yyoyd: Yeet, Yeety, Deet Deet, and Deeter.

TELL US ABOUT GOTCHA DAY.
During our meet and greet, he was so skinny and looked so helpless, but he was happy nonetheless. His whole butt wagged with his tail. The City Dogs volunteer said he'd get rescued fast because of his size, so I made the decision then and there that he was coming home with me.

WHAT ARE HIS FAVORITE THINGS TO DO?
He likes to start playing fetch with tennis balls but then decides to lie down and chew on the tennis ball instead. Other favorites are car rides and walks, and cuddling with Mom on the couch.

DOES HE HAVE ANY SILLY QUIRKS?
He has an underbite, so his tongue hangs out when he's sleeping. The longer he's asleep and the more relaxed he is, the more his tongue sticks out.

WHAT DOES HE MEAN TO YOU?
Strength to move on from my first rescue's passing. Lloyd gave me another chance to provide a deserving rescue with a loving place to call home and get all the love he deserves—and more!

—Jackie

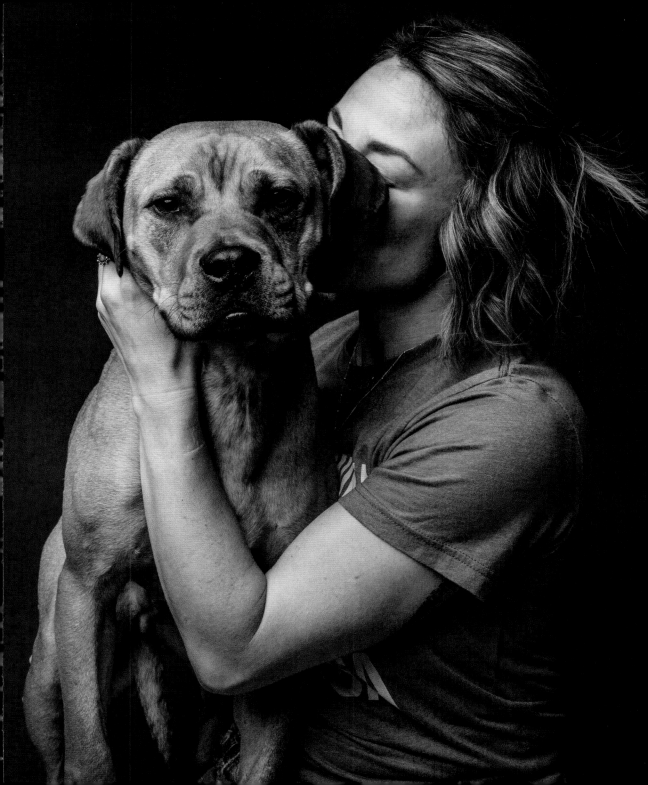

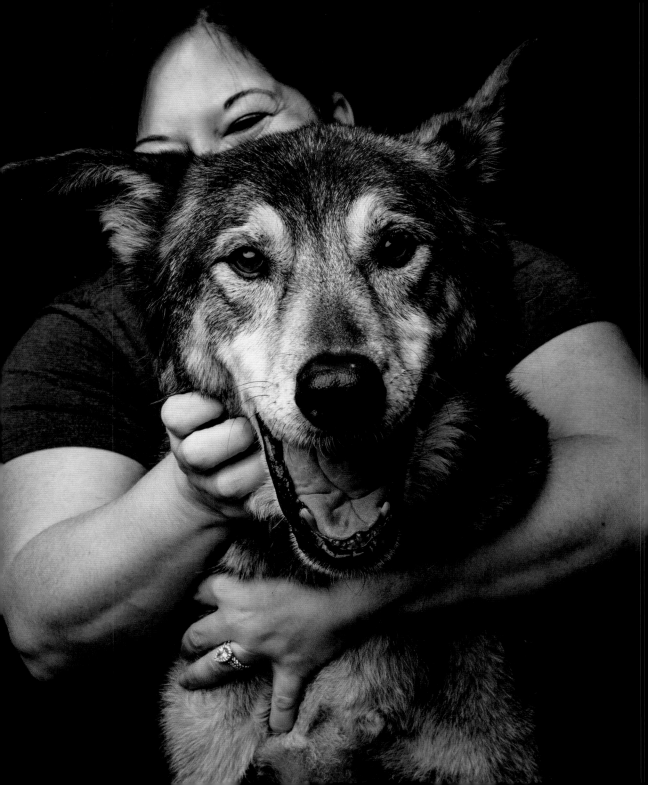

Brownie

GERMAN SHEPHERD AND GRAY WOLF MIX, 15 YEARS OLD

DID HE HAVE ANY NICKNAMES?
Walter, B-Dubs, Stubborn Old Man, Distinguished Gentleman

TELL US ABOUT GOTCHA DAY.
Brownie's owner passed away in October 2021, and his family was unable to continue to care for him. We have always wanted to adopt the oldest dog in a rescue, so when the opportunity for us to foster Brownie came, we could not pass it up. We knew we would be his last family, and we were okay with that. We were determined to make his remaining time enjoyable and comfortable.

WHAT WERE HIS FAVORITE THINGS TO DO?
He enjoyed naps on his big comfy bed and car rides to the pet store to get a bath, because he got a cheeseburger as a treat afterward. He loved to go for long walks, even if it was so cold and snowy—he was a true wolf.

His previous owner's sister found us on social media and shared so many stories. In his younger years, we were told that he roamed acres of land and enjoyed running along the fence line chasing the neighbor boy on his dirt bike.

DID HE HAVE ANY SILLY QUIRKS?
He would do anything for bologna. He was oh so stubborn. It was his way or no way!

WHAT DID HE MEAN TO YOU?
Brownie came into our lives after we had suffered a great loss. Caring for him was a distraction and a great one at that. He helped us heal. Brownie crossed the Rainbow Bridge June 11, 2022. He is now back with his original owner, eating all the good bologna.

ANYTHING ELSE WE SHOULD KNOW?
When we would take Brownie for walks around the neighborhood, many people would stop to ask us if he was a wolf. We thought they were all crazy—he was just a skinny, old German shepherd. But after a month or two of people saying the same thing, we decided to do a DNA test and found out Brownie was a German shepherd and gray wolf mix! We were shocked, to say the least.

—*Jen and Andy*

Maisy

| MOSTLY CHIHUAHUA AND DACHSHUND MIX, ABOUT 1 YEAR OLD

DOES SHE HAVE ANY NICKNAMES?
Maisy Moo, Maisy Mae, Maisers, Maiser-a

TELL US ABOUT GOTCHA DAY.
We saw a post about a litter of puppies where the mama died shortly after giving birth. They were all bottle-fed from day three, and the puppy pictures were so unbelievably cute. We also wanted to adopt a second dog to give our first rescue, Molly (page 55), a built-in friend and companion. It couldn't have worked out any better. We picked Maisy up from her foster mom, and she cuddled the whole way home. She instantly loved Molly.

WHAT ARE HER FAVORITE THINGS TO DO?
Maisy is all dog, all the time. She loves playing with her sister, tearing up her stuffed animals, eating apples, and hanging her head out the car window. She loves being outside, even if it's raining or snowing, which is strange for a doxie! She loves being picked up and held like a baby and cuddling right by my face when sleeping.

DOES SHE HAVE ANY SILLY QUIRKS?
Her DNA test showed some pit bull terrier in her, and we can totally see it in the way she walks or runs. She's got a lot of energy, but we call her "10 pm Maisy" because, like clockwork, once 10 pm hits, she's lying down and resting.

WHAT DOES SHE MEAN TO YOU?
She is our baby, and we think she is the sweetest dog. She is the definition of love!

ANYTHING ELSE WE SHOULD KNOW?
She ritualistically grooms Molly every night, licking her ears and face. She *loves* Molly so much. The two of them are like yin and yang—two totally different dogs and personalities, but they complement each other perfectly.

—*Amanda*

MOLLY (LEFT) AND MAISY (RIGHT) ▶▶

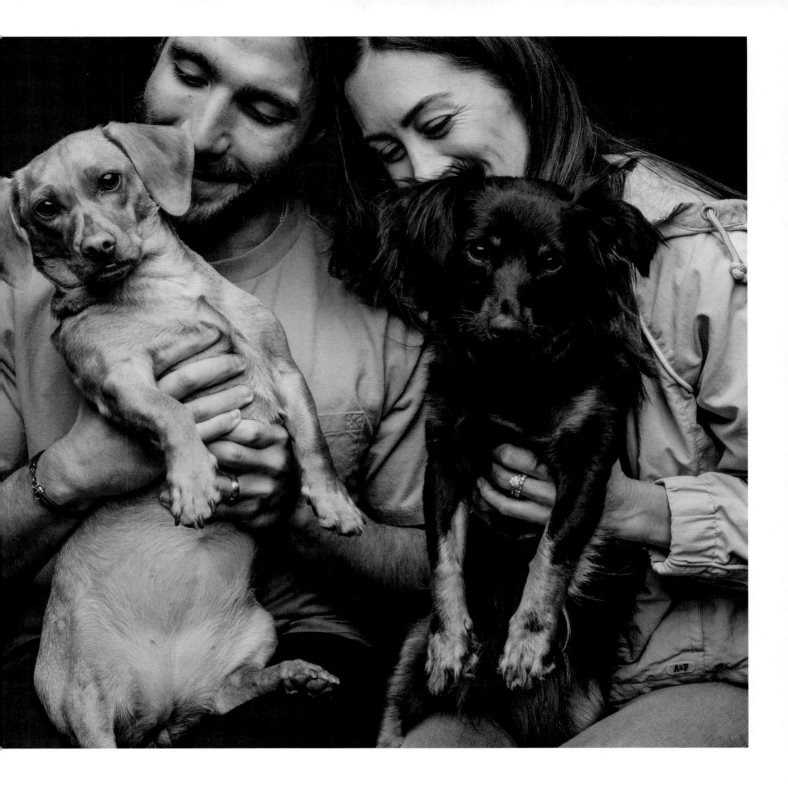

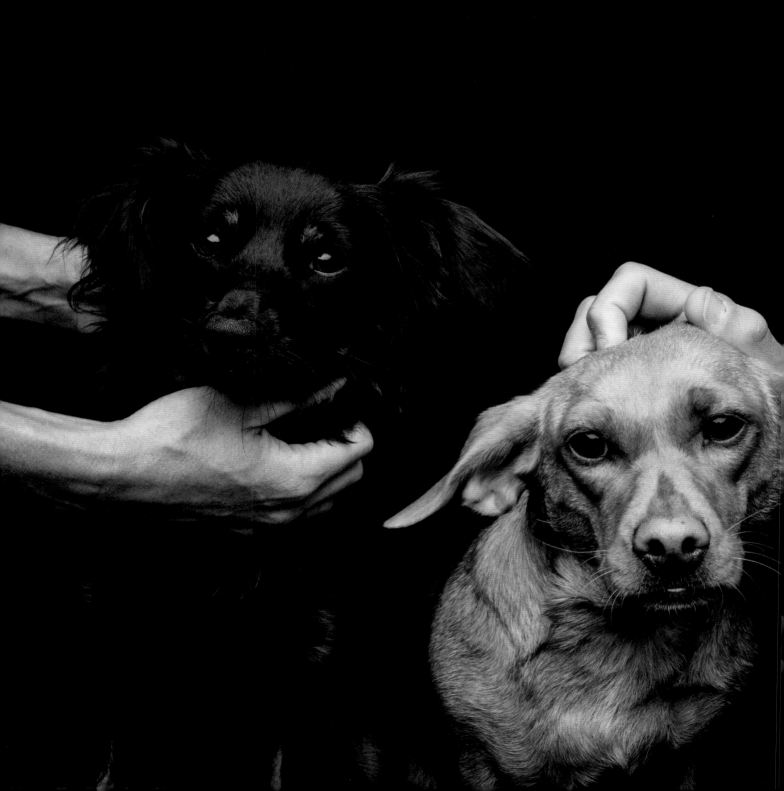

Molly

| DACHSHUND MIX, 2 YEARS OLD

DOES SHE HAVE ANY NICKNAMES?
Molly Moo, Moo, Moo-ington

TELL US ABOUT GOTCHA DAY.
We saw her picture and knew we had to be her parents. She was initially very sweet, but after a few weeks, her true spunky personality came through.

WHAT ARE HER FAVORITE THINGS TO DO?
Molly loves sleeping under the covers or wrapped up in her favorite blankets. She loves giving kisses, cuddling her humans, going for walks around the neighborhood, and being a ferocious guard dog.

DOES SHE HAVE ANY SILLY QUIRKS?
She has the cutest snarl where one of her teeth gets stuck on her upper lip.

WHAT DOES SHE MEAN TO YOU?
Everything. We truly love her more than anything. Just thinking about her can make a bad day great. She is the best thing that ever happened to us. She truly is the best dog—sweet and chill but also full of spunk and personality. A dog that loves to be loved and gives it right back. We love her endlessly.

ANYTHING ELSE WE SHOULD KNOW?
My husband proposed to me with Molly, and it was the first time meeting her. Talk about the best day ever!

—*Amanda*

◄◄ MAISY (LEFT) AND MOLLY (RIGHT)

June

| PIT BULL, 3 YEARS OLD

DOES SHE HAVE ANY NICKNAMES?
Junie, June Bug, Big Mama, Junie B. Jones

TELL US ABOUT GOTCHA DAY.
The first time I pet Junie, she closed her eyes and leaned against my leg. She was so sweet. She was underweight, and you could see the scar around her neck from where she had been tied up when she was abandoned. Somehow, she didn't have an ounce of hostility in her. And then she got to meet my other dog, Reed, and they got along immediately, which felt like a miracle.

WHAT ARE HER FAVORITE THINGS TO DO?
No dog in the world loves playing with other dogs more than Junie. She could play at the dog park all day, and she runs away when we try to go home. She's a big lap dog who will lay right on top of you. She loves car rides and walks but is very happy to just cuddle up on the couch and sleep.

DOES SHE HAVE ANY SILLY QUIRKS?
Junie is an absolute dope. She sometimes accidentally rolls right off the couch or runs into furniture. In the summer, she runs around the backyard and unsuccessfully tries to catch fireflies, but it's hilarious to watch. She loves to lay belly up on the couch and wants to meet every dog she comes across.

WHAT DOES SHE MEAN TO YOU?
She is an angel and means the world to me. It's hard to believe someone could have neglected such a sweet and loving animal. She is a part of the family and makes every day a whole lot brighter.

ANYTHING ELSE WE SHOULD KNOW?
Junie has chewed up about five TV remotes. I think it's to trick us into taking her on walks instead of watching TV.

—Alex

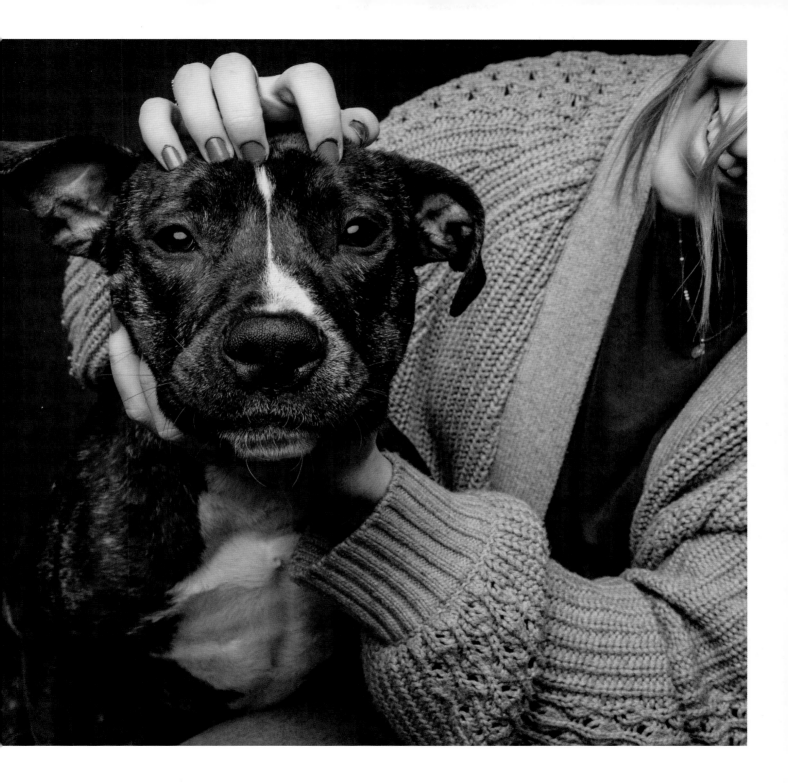

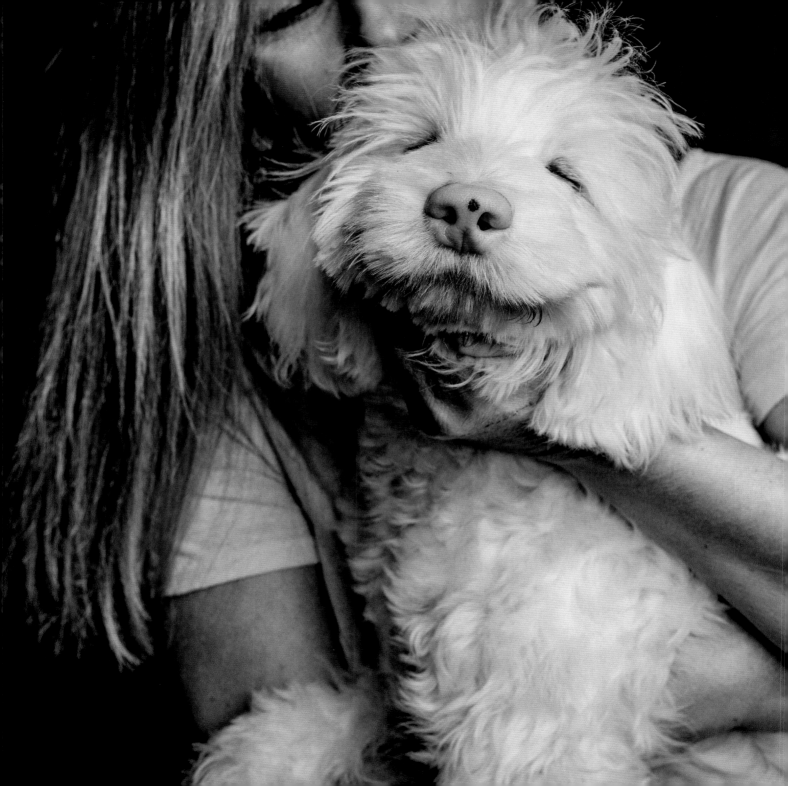

Otis

| DOODLE MIX, 1.5 YEARS OLD

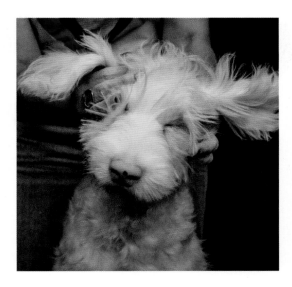

DOES HE HAVE ANY NICKNAMES?
Ots (pronounced "Oats")

TELL US ABOUT GOTCHA DAY.
Otis is both deaf and blind due to irresponsible
breeding, which could have been prevented!
I was able to save him due to the heroism of
Safe Harbor Rescue. I knew Otis was my soulmate when the rescue put him in my
arms. Due to his challenges, it was tough to figure out how to work with him. But Otis
taught me how to help him and was so patient with me. I knew we were meant to be
together.

WHAT ARE HIS FAVORITE THINGS TO DO?
Otis loves to play with scented floppy toys and cuddle on my lap while watching old
movies.

DOES HE HAVE ANY SILLY QUIRKS?
He gets the zoomies, which is typical for a seeing, hearing pup, but Otis took a long
time to feel comfortable in his yard and now loves to run like a crazy puppy!

WHAT DOES HE MEAN TO YOU?
Otis is my soulmate. He's shown me how to overcome challenges and live life to the
fullest.

—Zoe

Augie

| MOSTLY AMERICAN STAFFORDSHIRE TERRIER, 3 YEARS OLD

DOES HE HAVE ANY NICKNAMES?
Short Stack, Tinkyboy Bubs, Da Baby

TELL US ABOUT GOTCHA DAY.
When I went to the shelter to get a foster, he was not even on my list of dogs to see. For whatever reason, none of the dogs I went to see seemed like a good fit. I was told they had one dog who wasn't listed yet, but they thought I'd like him. They brought him in, and he came right to me, climbed into my lap, and gave me the sweetest little puppy kisses. I was like, "Yep, he is the one!" We left and never looked back.

WHAT ARE HIS FAVORITE THINGS TO DO?
Walks, naps, pibble-nibbling his daddy, zoomies, and snacking! We really enjoy working on his agility together, and he is getting more confident and skilled with every lesson.

DOES HE HAVE ANY SILLY QUIRKS?
He loves to wear bow ties and bandanas. He will sit and wait by his box for you to put one on him. He is so regimented and scheduled that he will nose, whine, or bark to let you know it's time to play or eat or whatever he thinks he needs at the moment. You can honestly set your watch by him!

WHAT DOES HE MEAN TO YOU?
The absolute world! He was a foster after those who came before him crossed the Rainbow Bridge, leaving a devastating emptiness in the world. After a few short weeks, we all realized we were meant for each other, and he became a foster fail.

ANYTHING ELSE WE SHOULD KNOW?
We went on a walk when he was still a foster and had only been with me for a few weeks. A little girl asked if she could pet Augie, and I told her that she could meet him and then we'd see about petting. I was apprehensive because I didn't know how he would react, but he sat right down and didn't move. When she reached out her hands, he flattened his ears and lowered his head into her upturned palms in the sweetest gesture I have ever seen in my life. I knew right then that he was a good boy and would have a great life ahead of him—but I didn't realize it would be with me! Now our mission is for both of us to be advocates for rescues and bullies, to help spread the word about all the wonderful *fur*iends waiting to meet you!

—*Scott*

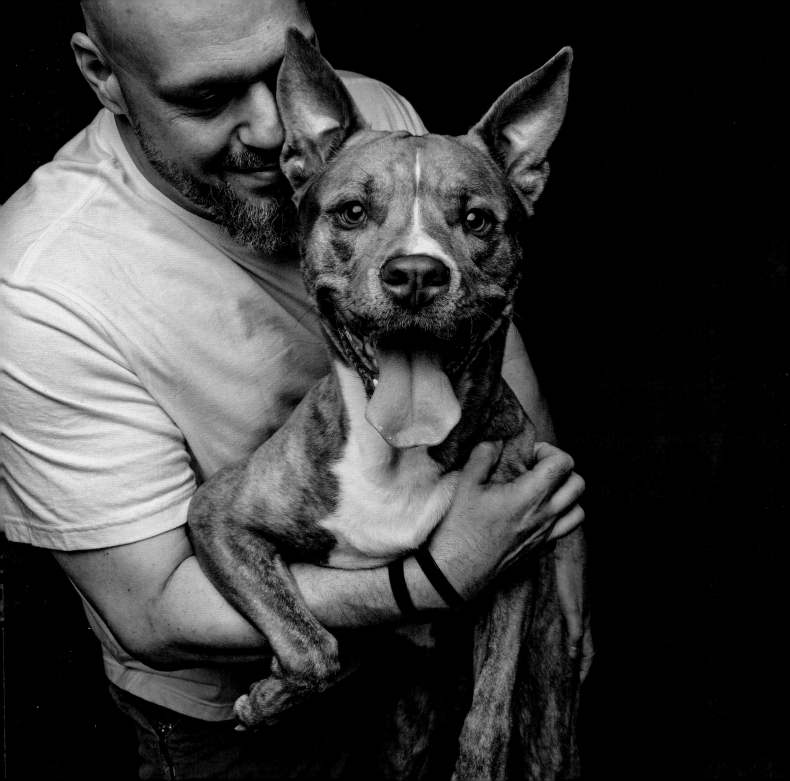

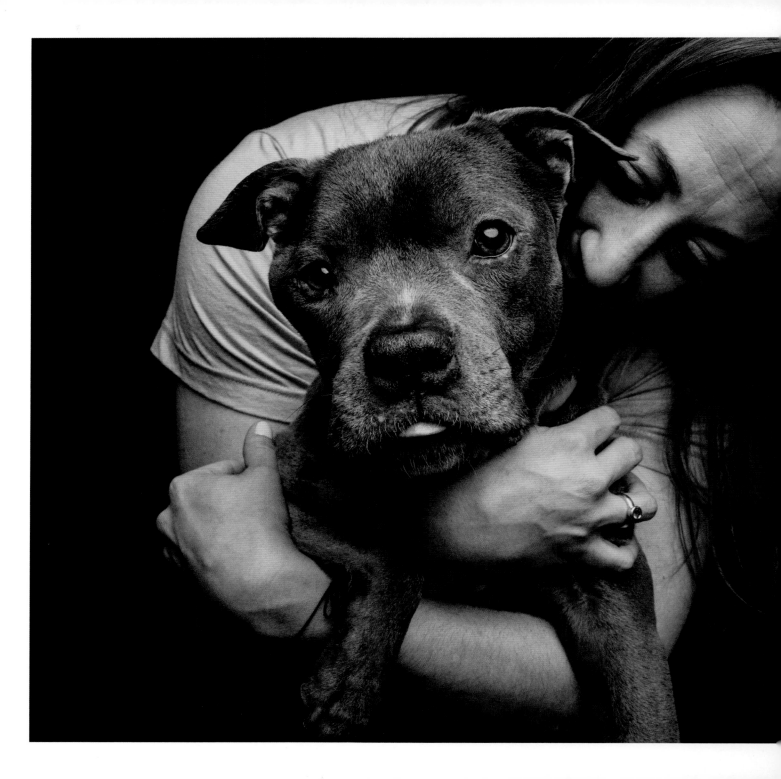

Mr. Wendal

| AMERICAN STAFFORDSHIRE TERRIER, ABOUT 14 YEARS OLD

DID HE HAVE ANY NICKNAMES?

Wendo and Peter Pan—because he was the most magical boy with a personality that could just take you away.

TELL US ABOUT GOTCHA DAY.

The kennel I volunteer at made a post about him that said he was about eighteen years old and had cancer. I couldn't imagine him spending another moment in a shelter, so I drove there the next day without even meeting him and took him home. It was the craziest and best decision I've ever made. As soon as we got home, I gave him the biggest hug. Instantly I was in love with this beaming ray of sunshine and every day with him was the best day.

WHAT WERE HIS FAVORITE THINGS TO DO?

He couldn't resist the opportunity to meet a new friend. He loved anyone he met—a person, another animal, even the vet—and he could hardly contain his exuberant personality in his little body. Snuggling his humans or fur family was his favorite thing, next to curling up by the fireplace and looking out the window to watch the squirrels and birds.

DID HE HAVE ANY SILLY QUIRKS?

He snorted like a pig when he would get overly excited. He also always had to find something to greet you with. It could be anything; he once carried the cat scratch tree that was almost as big as he was!

WHAT DID HE MEAN TO YOU?

Mr. Wendal meant comfort. He felt like home and gave me confidence, like we could do anything or go anywhere without a worry in the world. He was an inspiration to make the most of every day. A true angel in disguise, an actual unicorn.

ANYTHING ELSE WE SHOULD KNOW?

He lived like every day was the absolute best. We don't believe he was eighteen, but more like fourteen. His misshapen head was the result of a neurological cancer that paralyzed half of his mouth, making it very difficult for him to eat and drink, which led to other complications. Mr. Wendal crossed the Rainbow Bridge in my arms on April 7, 2022, after a short eight months together—but they were the best eight months of our lives.

—Emily

Jordan

| PIT BULL, ABOUT 4 YEARS OLD

DOES HE HAVE ANY NICKNAMES?
Juicy J!

TELL US ABOUT GOTCHA DAY.
Jordan had been at the shelter for months. Every so often, a photo of him would pop up, and we would joke about going to get him. On his six-month anniversary of being at the kennel, we decided to meet him. After our first meeting, we wondered why no one had chosen him yet. He is gorgeous, smart, and hilarious. I turned to look back at him as we walked to our car, and he was at the end of the leash watching us leave, despite the hustle and bustle of the busy area. I knew in that moment that he was our boy. And we began the process of introducing him to our girls and bringing him home. He'd been at the shelter for seven months before it was official. He had just been waiting for us to realize we were ready to open our hearts.

WHAT ARE HIS FAVORITE THINGS TO DO?
Jordan loves snuggles, playing with his doggy sisters, barking with the neighbor dog two houses down, and most of all, he loves food!

DOES HE HAVE ANY SILLY QUIRKS?
He loves to climb in your lap and rub his face against you like a giant, overgrown kitten. He is always talking and is a noisy boy who likes to express himself, sometimes quite loudly. He is obsessed with food and will blow drool bubbles while he waits for dinner or treats!

WHAT DOES HE MEAN TO YOU?
Jordan filled the hole in our hearts and home after we lost our two previous dogs over the last few years. We (and his three pittie sisters) didn't know if we were ready to bring another dog in, but when we met him, it was apparent he was meant to be a member of our family. He brought the dopey boy energy back into our home. He's

continued ▶▶

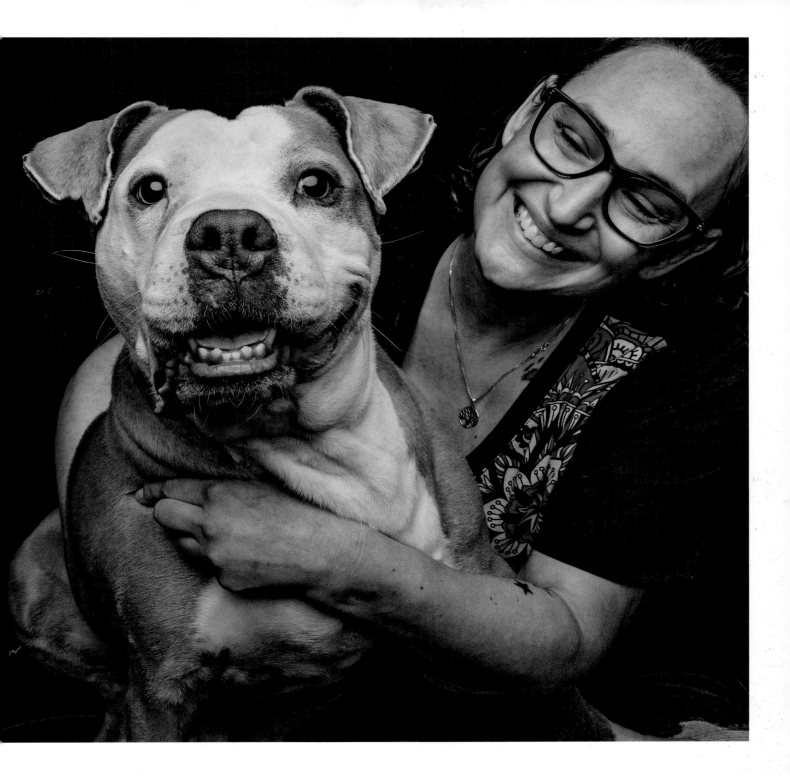

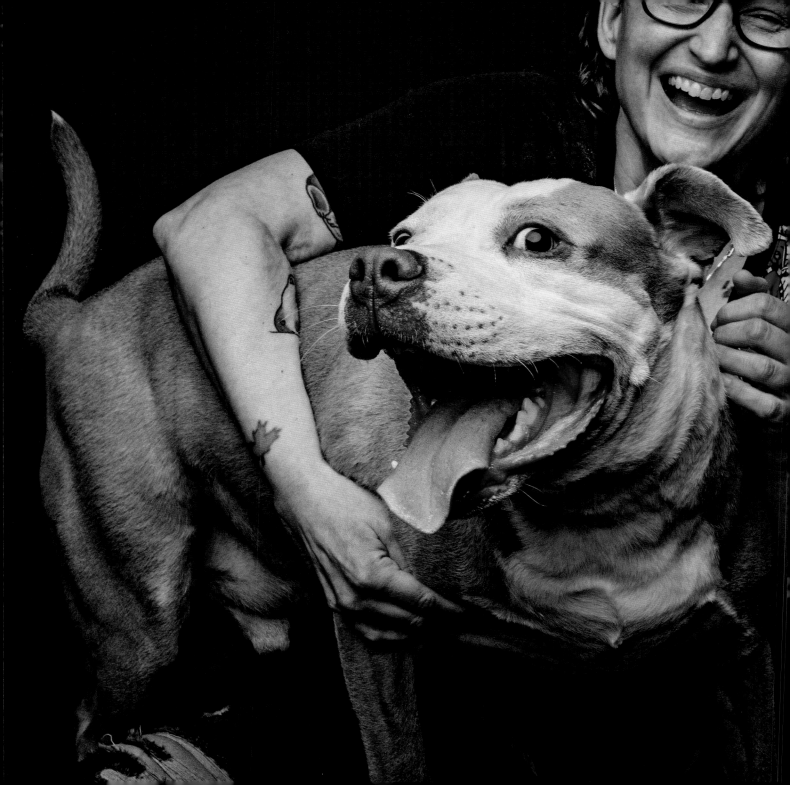

one of the funniest dogs we've ever had, and he really has brightened up our days! He has his quirks and challenges, but we love him so much—and love watching him learn and grow into the best boy we could've asked for.

ANYTHING ELSE WE SHOULD KNOW?
He's a heartworm survivor, doesn't have a mean bone in his body, has no clue how big he is, and loves everything and every minute of each day! He is so full of joy and innocence that even when he's up to no good, running around with your shoe in his mouth, you can't help but laugh. We do what we can to remind him that he is safe and loved and will never be neglected, hurt, or discarded again.

—*Carla*

"When we met him, it was apparent he was meant to be a member of our family. He brought the dopey boy energy back into our home."

Dante

BASSET HOUND, 3 YEARS OLD

DOES HE HAVE ANY NICKNAMES?
His full name is Dante Herbie Hancock Adamich, but we also call him Meatball,
Dante Shark, Sweet Babboo, Air Dante, Chompy, and Bro Bro.

TELL US ABOUT GOTCHA DAY.
When we heard Dante had a rough go in life and that he would be a project, we
knew we were the family for him. He suffered an injury when he was about a year old
that caused the removal of three-quarters of his tail, and he has had three surgeries
to reattach it. He is very nervous around new people due to his injury and having
been home a lot because of the pandemic (he was born right before it started). They
thought he would thrive in a home with a family. We were completely broken, he was
broken, and we needed one another more than we knew. Even though he can be
super anxious at times, he is the absolute zen of our household and has superpowers
to keep us calm when we are anxious.

WHAT ARE HIS FAVORITE THINGS TO DO?
Napping on top of the couch, snacking on beef tips, sunning himself in the backyard.

DOES HE HAVE ANY SILLY QUIRKS?
We joke around that even though basset hounds are French, Dante identifies as
Italian. He loves to go up to our tomato plants, pick the tomatoes, and eat them. His
snooter does air circles for the smell of Italian food, he is drawn to the color red, and
we found him napping with a postcard a friend sent us from Rome. We could not
have picked a better name for him!

WHAT DOES HE MEAN TO YOU?
Dante means the world to us. He comforted us after our beloved basset, Bernie,
passed away unexpectedly after twelve years with us. Even though Dante needed
to heal on his own, he still assisted us in our healing process—and for that we are
forever grateful.

ANYTHING ELSE WE SHOULD KNOW?
Dante shares a birthday with Betty White!

—Brinley

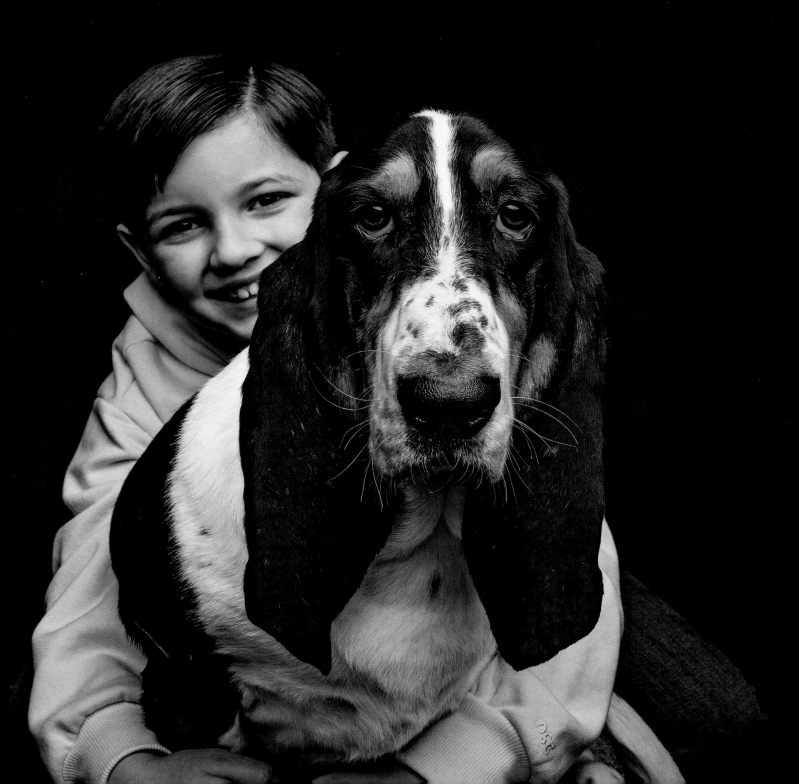

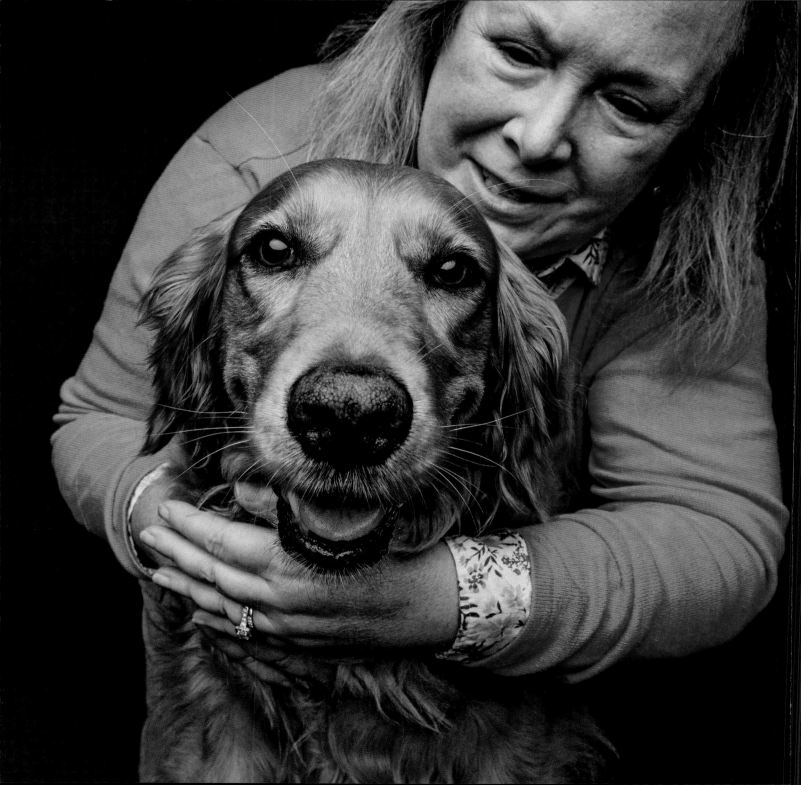

Bailey

| GOLDEN RETRIEVER, 4 YEARS OLD

DOES SHE HAVE ANY NICKNAMES?
Bailey Brown, in honor of our other female dog who passed before she came into our lives, whose name was Honey, but who we called Brown since she was chocolate brown. Sometimes we just call her Bay.

TELL US ABOUT GOTCHA DAY.
Unfortunately, we think she was probably mistreated before being rescued, since she is very fearful of brooms, loud noises, and sudden movements. She especially hates the vacuum and thunderstorms. She was a little skittish at first but quickly warmed up when Remy (page 72) started playing ball with us. I think she was convinced that we were people who provided yummy treats and lots of pets. Like with Remy, we knew they would be a perfect pair for our home, which was very empty without a canine or two.

WHAT ARE HER FAVORITE THINGS TO DO?
Bailey is a redheaded couch potato. She would rather skip a potty break to sleep. When she isn't napping, she enjoys wrestling with her BFF Remy, doing zoomies in the backyard, and barking at squirrels. Bailey and Remy love taking walks with Mom and being oohed and ahhed at by everyone who meets them along the way.

DOES SHE HAVE ANY SILLY QUIRKS?
She cannot catch a treat or a ball to save her life. She pretends not to be athletic but is amazing at weaving through the backyard arborvitae. We think she could easily become an agility dog.

Bailey is very protective of Remy. If he gets scolded, she will put her body in between him and me. She tries to take all the blame for everything that he does. She loves him with all her heart.

ANYTHING ELSE WE SHOULD KNOW?
We are honored Remy and Bailey are with us. They make our house complete—along with our rescue cats, Scrawny and Fry.

—*Karen*

Remy

GOLDEN RETRIEVER, 4 YEARS OLD

DOES HE HAVE ANY NICKNAMES?
Remy Remington Fluffypants because his "pantaloons" or tail feathering is especially blond and fluffy.

TELL US ABOUT GOTCHA DAY.
Remy was strikingly blond but so skinny. We had an instant connection over a ball, and I knew he and his bestie, Bailey (page 71), were meant to be ours.

WHAT ARE HIS FAVORITE THINGS TO DO?
Catching tennis balls, biting his best bud Bailey, ambushing those who walk by our (fenced-in) backyard and sounding ferocious, snoozing on the couch instead of the dog bed, herding our two rescue cat.

DOES HE HAVE ANY SILLY QUIRKS?
Remy loves to lie on his back—spread eagle—and nap. He has no modesty. There's not a treat that he can't catch. He loves a banana with an ice cube chaser.

WHAT DOES HE MEAN TO YOU?
After losing my heart dog—my soulmate, Sam—and another rescue, Honey, I didn't think I would want dogs for a while. I knew when I was ready, I wanted a bonded pair—but I never thought it would happen so quickly. But Remy and Bailey were supposed to be with us. Sometimes you have to adjust your internal schedule to accept who and what was meant to be in your life.

ANYTHING ELSE WE SHOULD KNOW?
If Remy were a human, he'd be the blond jock who is on the high school football team but who also has a tender side.

—Karen

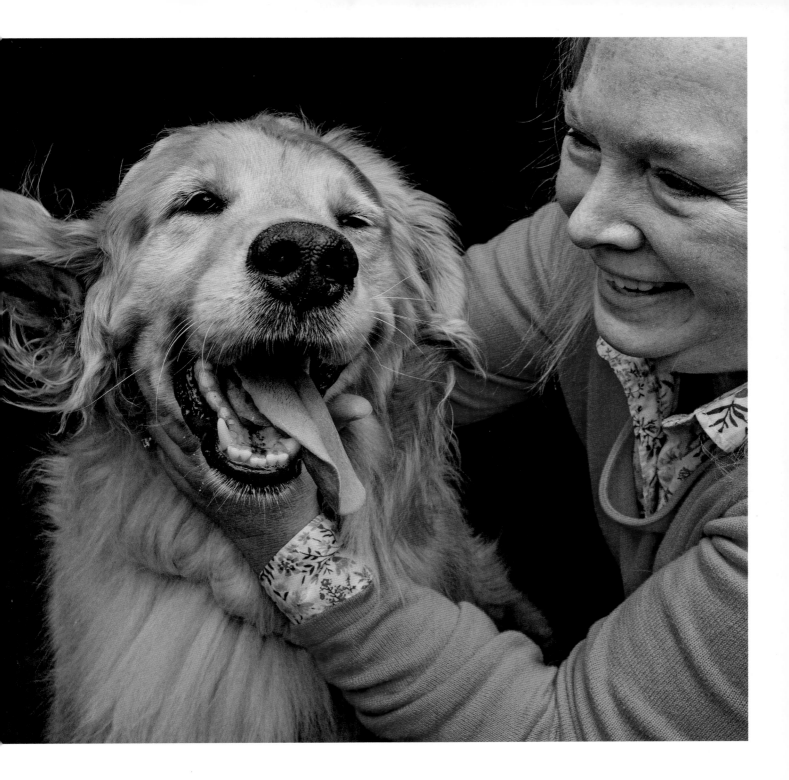

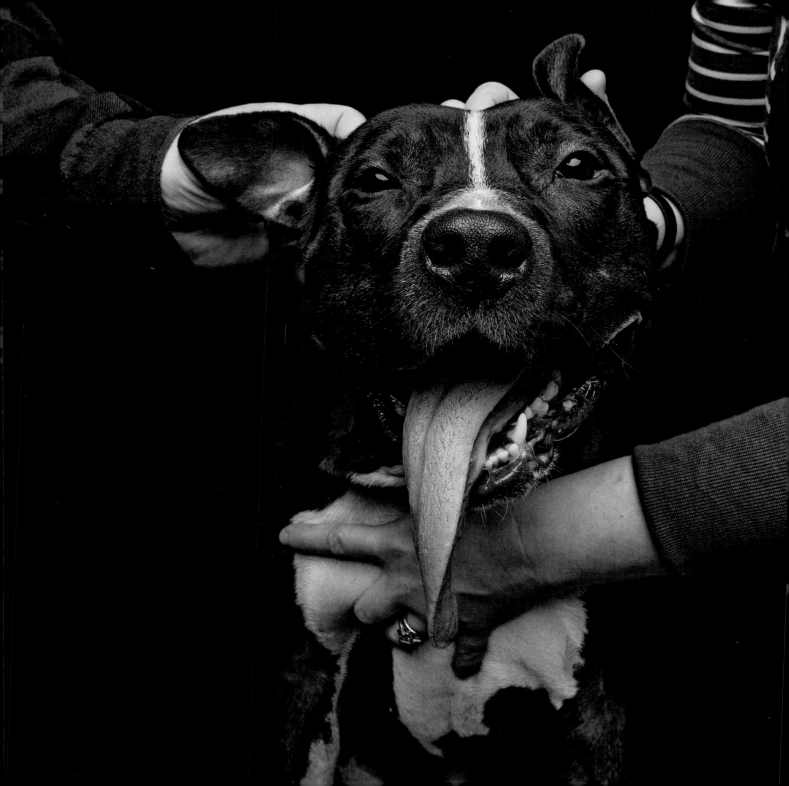

Mork

STAFFORDSHIRE BULL TERRIER AND
PIT BULL MIX, ABOUT 2 YEARS OLD

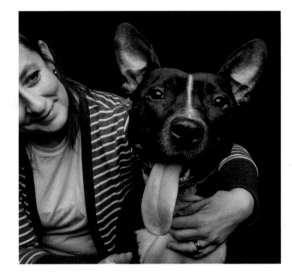

DOES HE HAVE ANY NICKNAMES?
Morkie, Morkie the Porkie

TELL US ABOUT GOTCHA DAY.
I followed the kennel Mork was at on social
media, and it was breaking my heart how long
he had been there without any visitors. He seemed like such a mild-mannered pup,
and the volunteers said he was so sweet. We set up a meet and greet, and it went
great! We did a trial adoption for a week, but my husband and I already knew he
was moving in with us.

WHAT ARE HIS FAVORITE THINGS TO DO?
He loves, loves, loves his ball. He enjoys doing whatever his fur siblings are doing:
going on walks, laying in the sun, and snuggling on the couch.

DOES HE HAVE ANY SILLY QUIRKS?
He is a very quirky dog! His tongue hangs out all the time, and that adds to his sweet
silliness. He also loves to bring our shoes to us, then run off with them as he snorts
and wiggles his butt. He never chews on them, though! His tail is always wagging.
And when you pet him, his tail wags even faster, and he'll spin in circles and snort the
whole time. It's hysterical!

WHAT DOES HE MEAN TO YOU?
Mork—and our other two rescue pups—means the world to us. There's nothing better
than the love they show us and each other. They make me smile so much every day.

—*Carly*

Rowlie

| GREYHOUND, 3 YEARS OLD

DOES HE HAVE ANY NICKNAMES?
Rowl. His full name is Mr. Rowlie Appledore. I'm a Tolkien nerd!

TELL US ABOUT GOTCHA DAY.
Rowlie came in excited to meet us and immediately put his head in my lap for a hug. I knew he was the one the second I met him. But he went through quite an adjustment period when we adopted him, and we quickly discovered he has separation anxiety. He's happy as long as he can be with us or our other dog, Beren. He's a wonderful dog, and I couldn't imagine my life without him.

WHAT ARE HIS FAVORITE THINGS TO DO?
He loves to go for walks, meet new people, and get Pup Cups. He also loves zoomies and new toys.

DOES HE HAVE ANY SILLY QUIRKS?
He likes to gather things from around the house (especially clothing items) and put them on his bed. He also likes to put himself to bed around 8 pm each night.

WHAT DOES HE MEAN TO YOU?
He lights up my life, along with my other greyhound, Beren. We adopted Rowlie about nine months after we lost my soulmate dog, Arwen. While he doesn't replace her, he helps fill the hole in my heart that was left when she passed. He's a happy, sweet, goofy boy who always makes me smile (even when he's bad!).

ANYTHING ELSE WE SHOULD KNOW?
Rowlie is a retired racer. He ran fourteen races before he was two years old and won only one.

—Leanne

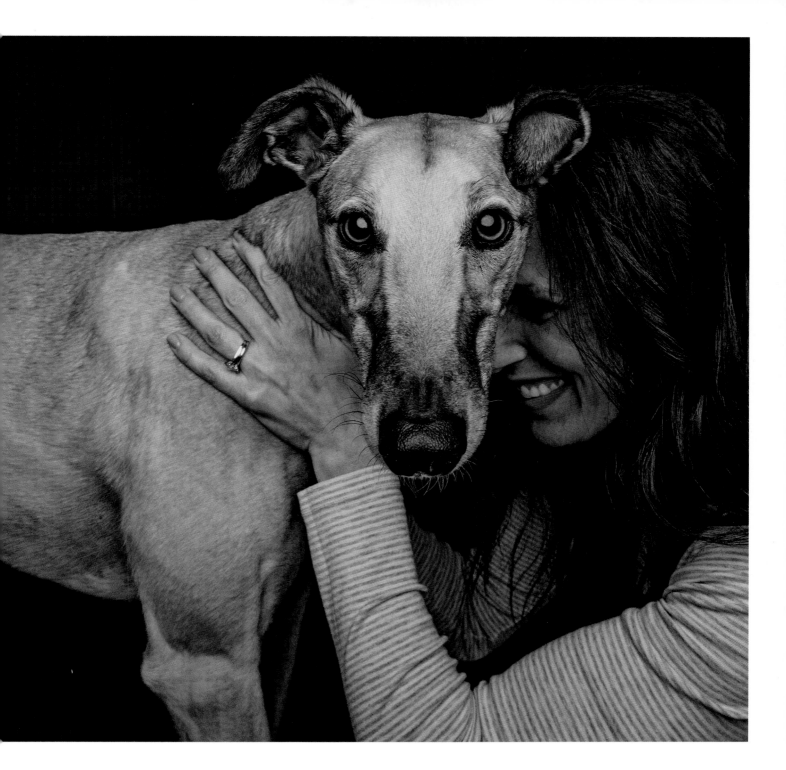

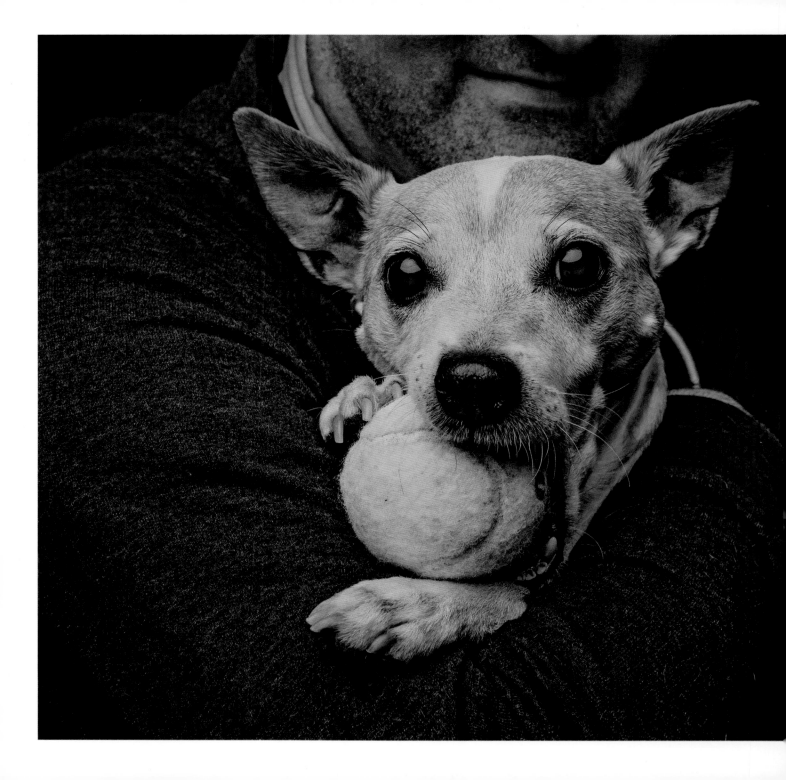

Rosey

JACK RUSSELL TERRIER MIX, ABOUT 11 YEARS OLD

DOES SHE HAVE ANY NICKNAMES?
Patricia Rose, Rosalita, Piglet, Pookie

TELL US ABOUT GOTCHA DAY.
Rosey was found as a stray and brought to the kennel at approximately ten years old. She had a large, cancerous tumor on her foot and several mammary tumors. The rescue needed a medical foster to care for her surgeries. I learned that all her fosters had backed out and that this tiny senior dog was at a boarding facility in a vet's office. She hated it in there, as you can imagine. I couldn't leave her and convinced my husband that we should foster her. Obviously, we fell in love and adopted her soon after.

From the second we met her, she absolutely adored my husband. She has to be on his lap or next to him at all times. She loves me, too, but her love for Sean is adorable. She let him pick her up when we first met her, and I think it was love at first sight.

WHAT ARE HER FAVORITE THINGS TO DO?
Rosey loves car rides to the park and snuggling on the lap of her favorite human. She also likes solving challenging puzzle toys and finding treats wherever we hide them.

DOES SHE HAVE ANY SILLY QUIRKS?
No matter how much you feed her, she stands in the kitchen at night silently demanding food. She also plops onto her dad's head promptly at 6 am every morning to let him know it's time to get up.

WHAT DOES SHE MEAN TO YOU?
We got Rosey shortly after losing another beloved dog, and from the day we brought her home, she's been the best companion we could have asked for. Because she always wants to be in your lap, she is a consistent source of warmth (literally and emotionally), love, and support. She's the perfect ride-or-die partner in crime and the best friend that we could ask for. She's such a tough cookie. And as a cancer survivor—in addition to whatever else she went through the ten years before we met her—she's an inspiration to me as well.

—Jessica

Arch

| **TOY POODLE MIX, 12 YEARS OLD**

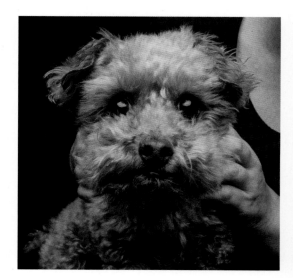

DOES HE HAVE ANY NICKNAMES?
Little

TELL US ABOUT GOTCHA DAY.
When we got to the shelter and sat down,
Arch jumped right up into my lap. He had
lots of snaggleteeth, was underweight,
and had a mop of a hairdo, but he was still Mr. Charming and won us over!

WHAT ARE HIS FAVORITE THINGS TO DO?
He loves running through Lakeview Cemetery, listening to NPR on the couch when
I'm at work, and playing fetch with his toy lobster.

DOES HE HAVE ANY SILLY QUIRKS?
Arch has more hand-knitted sweaters from his grandma than he does teeth. He also
requests a new entrée flavor every few days.

WHAT DOES HE MEAN TO YOU?
He's my little pal and brings a whole lot of joy per pound—he only weighs six!

—Abby

"He had lots of snaggleteeth, was underweight,
and had a mop of a hairdo, but he was
still Mr. Charming and won us over!"

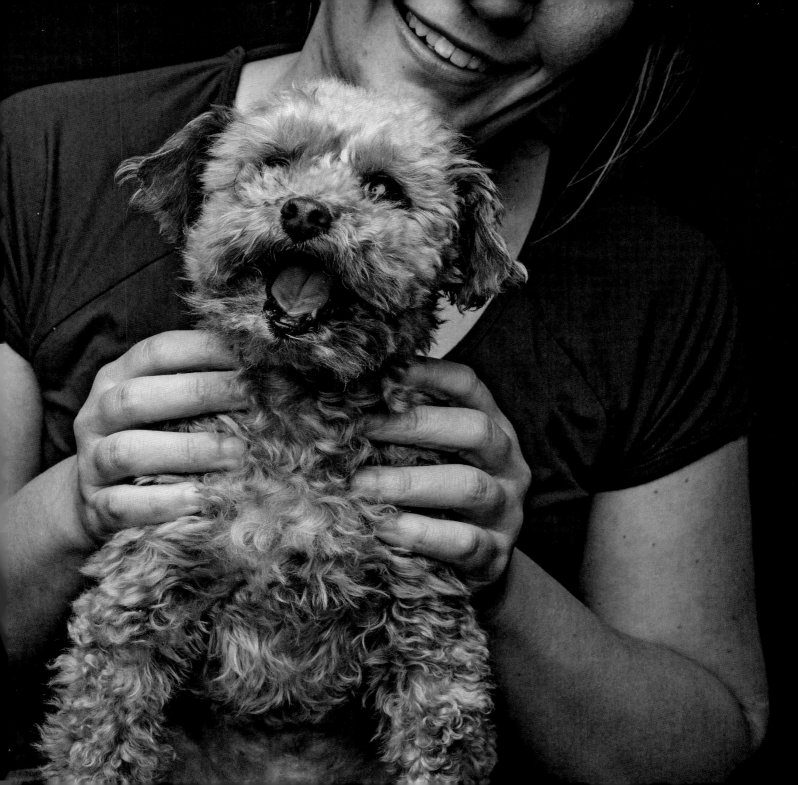

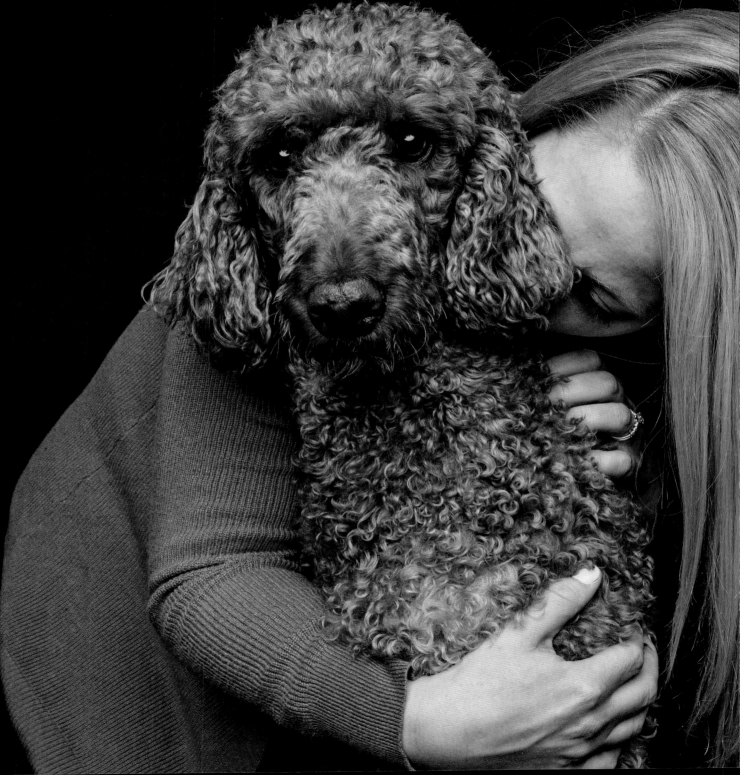

Pretzel

| STANDARD POODLE, 5 YEARS OLD

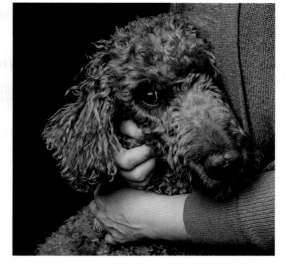

DOES SHE HAVE ANY NICKNAMES?
Pretzel Elizabeth—we call her Pretzy Betzy!

TELL US ABOUT GOTCHA DAY.
Pretzel has only three legs. She lost her front leg in an accident prior to being adopted. Because she had been a breeding dog and wasn't able to carry more litters after her amputation, she was surrendered to the rescue. She has very soulful eyes, and I knew she needed a special home. We brought the whole family (me, my husband, and two other dogs) to the rescue to meet her, and she was so timid. She was shy and overwhelmed, but she took a few treats gently from my hand. My husband also realized what a sweetheart she was, and we knew she would be a great addition to the family!

WHAT ARE HER FAVORITE THINGS TO DO?
Pretzel is the sweetest couch potato I've ever met. She loves going on walks, taking car rides, and being near her family. She is patient and kind around all people, including children and the elderly, so we are working to become a therapy dog team. Pretzel has even started visiting some nursing homes with me.

DOES SHE HAVE ANY SILLY QUIRKS?
Pretzel loves kisses and will barge her way into my space if she hears me giving some love to my other dogs, Scrabble and Lincoln. During her first few months, we discovered she is a counter surfer! Her favorite items are silicone spatulas and our TV remote. We have since learned her quirks and Pretzel-proofed the house.

WHAT DOES SHE MEAN TO YOU?
Pretzel is my child and family member. She had a rough start to life, and I tell her every day she "just gets to be a dog now."

—Lisa

Leo

GERMAN SHEPHERD, 1 YEAR OLD

DOES HE HAVE ANY NICKNAMES?
Leo Man, Sweet Man, Best Boy

TELL US ABOUT GOTCHA DAY.
I love German shepherds and hadn't had one for about seven years. I first saw Leo online and felt called to him, but we weren't looking for another dog at the time. A couple of days later, at dinner with family, my sister-in-law brought up that an acquaintance was fostering a "beautiful, sweet German shepherd" who only had three legs. I thought this couldn't be just a coincidence—that it had to be Leo—and I knew I had to go see him.

We were all unsure during the first meeting. Leo was wary of new faces, particularly of men, but he warmed up to our six-year-old daughter, then me. We could see a softness in him and decided to come back with our other dog. Seeing her with us shifted something in Leo. He trusted us a bit more. He was fresh out of surgery and needed a home for his recovery. We decided to give him a chance.

WHAT ARE HIS FAVORITE THINGS TO DO?
Chasing his pit bull big sister, Kyrie Jane, laying in the sunshine, snuggling on the couch or bed, going on walks around our property.

DOES HE HAVE ANY SILLY QUIRKS?
It's hard not to laugh at him hopping around on three legs! He's so spunky and happy, his tongue always hanging out of his smile and tail wagging. He tosses his toys for himself, will smell your breath, and tattles on his sister if she loses the backyard balls.

WHAT DOES HE MEAN TO YOU?
Leo felt like the completion of our family during this chapter in our lives. He's a best buddy to Kyrie Jane (my husband and I joke she's Leo's emotional support animal), a fierce protector of our home, and a loyal and affectionate companion.

—Jessica

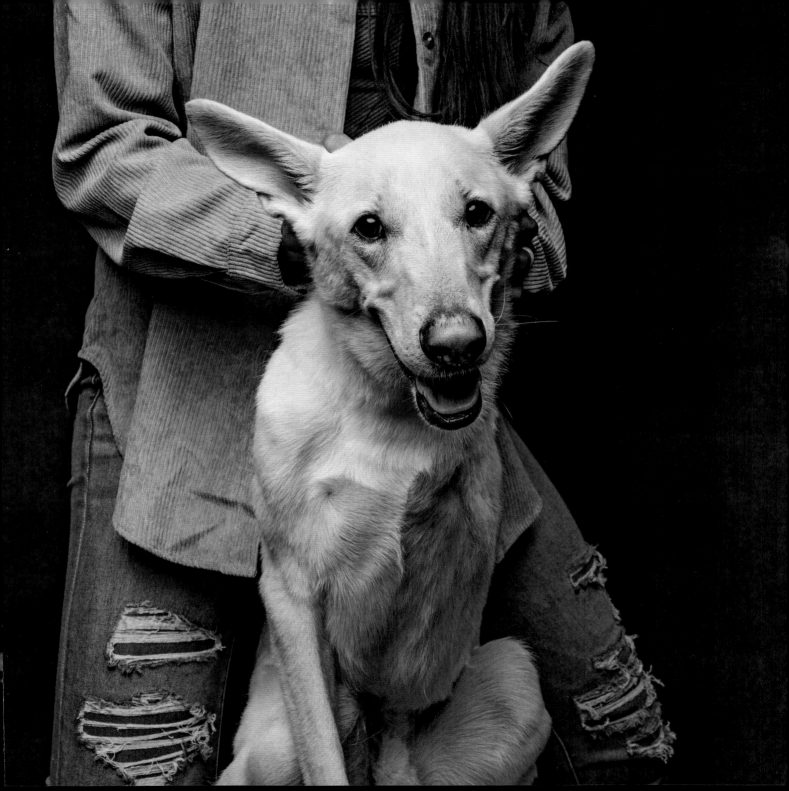

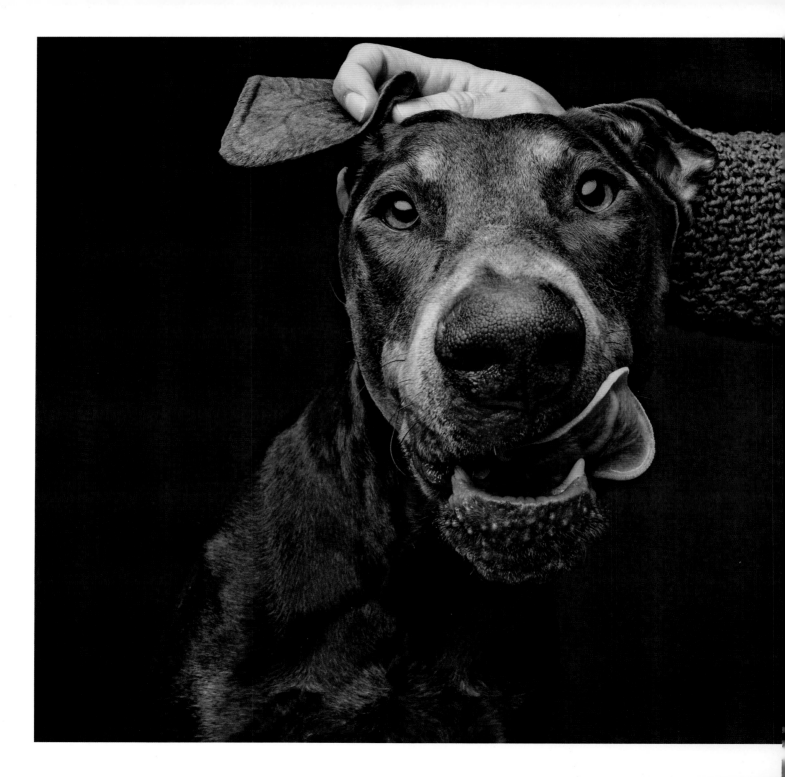

Ritter

| DOBERMAN, ABOUT 2 YEARS OLD

DOES HE HAVE ANY NICKNAMES?
Ritter Ritter Chicken Dinner, Ritter Critter, Rit, Uncle Ritter

TELL US ABOUT GOTCHA DAY.
Ritter came to us because a family needed to rehome him when they couldn't give him the attention his medical needs required. Our first meeting was a mess! I took my other dog, Summit, hoping they'd hit it off right away. Ritter was completely uninterested in me, obsessed with my other dog, and showed me all his worst (frustrated) behaviors that would need to be worked on. I should have run, but I couldn't stop thinking about him and how he needed a chance. I knew I would be bringing him home with me.

WHAT ARE HIS FAVORITE THINGS TO DO?
Ritter loves going to daycare; taking walks (especially with other dogs); attending training class and practicing what he's learned; shredding toys, boxes, and blankets to pieces; going on car rides; and helping take care of fosters (especially puppies).

DOES HE HAVE ANY SILLY QUIRKS?
He has this funny way of sitting on people: If you are sitting down, he will rest his bum on your lap and keep his front legs on the floor. He will sit on his doggy sister, Summit, or with his bum on the armrest of chairs and his front legs on the seat.

WHAT DOES HE MEAN TO YOU?
Ritter, like all of our dogs, means everything to us. He is our life! He lives every day like it's the best day of his life, and that zest makes my life happier!

ANYTHING ELSE WE SHOULD KNOW?
I would love to press for the importance of researching questions to ask breeders before buying a dog. Ritter has Von Willebrand disease, a blood-clotting disorder very common in Dobermans. This is a serious condition, and his parents should have been tested for it prior to breeding.

—Bryana

Derpy

PIT BULL MIX, 2 YEARS OLD

DOES HE HAVE ANY NICKNAMES?
Derp

TELL US ABOUT GOTCHA DAY.
When he was first dropped off at our house, we had no plans to keep him. But he arrived and immediately got the zoomies, sprinting back and forth across our backyard. He then came inside and ran around the house because he was so happy to be inside. After that, he curled up in a ball on our couch and passed out with a giant grin on his face. We knew we would have a hard time letting him go.

WHAT ARE HIS FAVORITE THINGS TO DO?
Going for walks, playing fetch, and watching the sunset.

DOES HE HAVE ANY SILLY QUIRKS?
Derpy is very vocal and expressive when he wants something. He regularly army crawls to get around. When you call him in from being outside, he will sprint too fast to the porch and run straight into the door.

WHAT DOES HE MEAN TO YOU?
Because he was spontaneously left with us, I feel as if he was meant to be here. He gets along with our family so well, and he has a special place in our house.

—Sarah

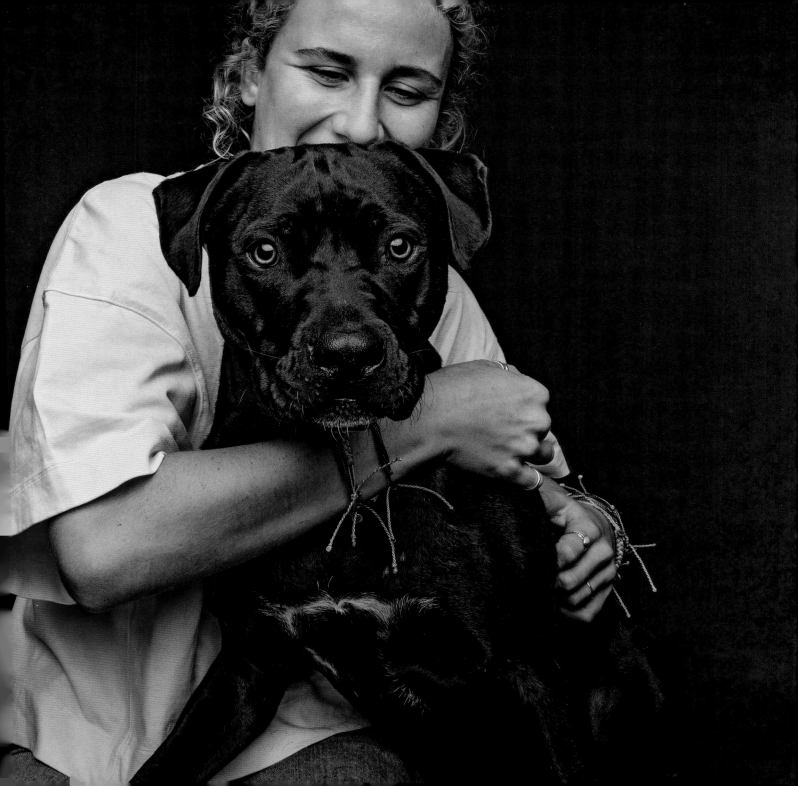

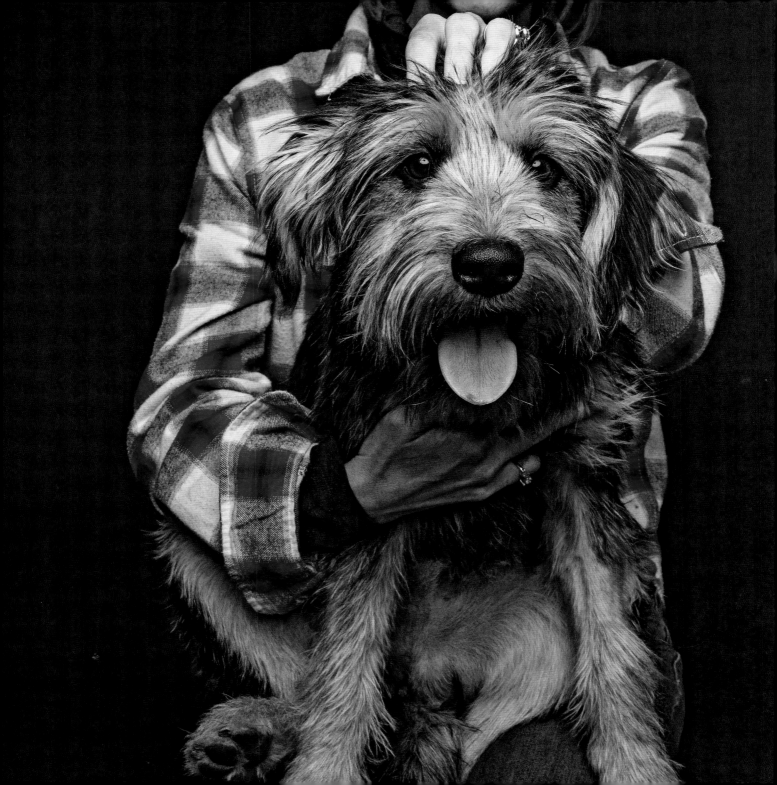

Scruffy

YORKIE AND AIREDALE TERRIER MIX, ABOUT 1 YEAR OLD

DOES HE HAVE ANY NICKNAMES?
Scruffin McMuffin, Mr. McMuffin, Scruff, Muffin

TELL US ABOUT GOTCHA DAY.
Scruffy came to us with his two brothers as fosters. His previous family had been a nightmare. He was hit, locked in a garage when they went out of town, kicked into a space heater when they returned for having an accident not on a pee pad—at just ten weeks old! The kick resulted in burns to his leg, thigh, and paw. This poor guy was broken, afraid of people, and had lost all confidence in himself. It took around two weeks until we could hold him or pet him without him running away. My husband and I knew this pup needed us to be his forever family.

WHAT ARE HIS FAVORITE THINGS TO DO?
Scruffy is an active little guy. He loves to run, jump, bark, and play with his four-legged siblings. He likes to dig in the backyard. He dug a tunnel under the deck and has gotten stuck more times than we can count. He snuggles at night and keeps your feet warm.

DOES HE HAVE ANY SILLY QUIRKS?
Scruffy thinks he is a cat and will sleep on the back of the couch, on the top of his cage, or on the table.

WHAT DOES HE MEAN TO YOU?
He is the joy that puts a smile on your face and the pup that keeps you guessing about what he will try next.

—Heather

Tilly

| PUG, 2 YEARS OLD

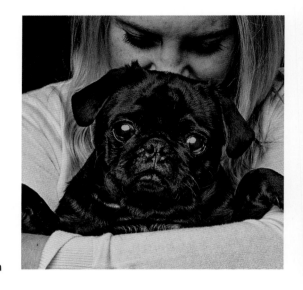

DOES SHE HAVE ANY NICKNAMES?
Till or Till Till

TELL US ABOUT GOTCHA DAY.
She came from a puppy mill. She had been bred recently and was extremely skinny and terrified of everything. She was so tiny and had the sweetest face. I just knew I had to adopt her and give her the best life.

WHAT ARE HER FAVORITE THINGS TO DO?
Going on walks, playing with toys, snuggling on the couch, and following around her pug sister, Frannie.

DOES SHE HAVE ANY SILLY QUIRKS?
She sings when she is excited, when she comes in from a walk and is waiting for a treat, or when you pull her food out of the cabinet, and she is waiting to eat. She sings for her supper!

She loves to look at her reflection on car doors. When we are out for walks and there is a dark-colored car parked on the street, she will walk up to it and look at herself.

WHAT DOES SHE MEAN TO YOU?
Smiles and pure happiness. Tilly makes me laugh with her energetic personality.

—Julie

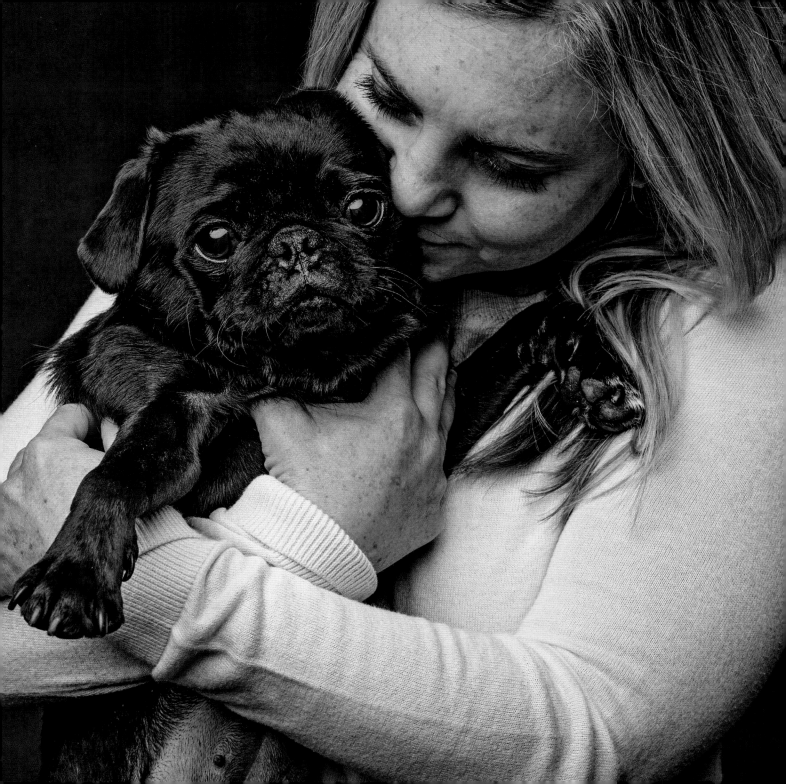

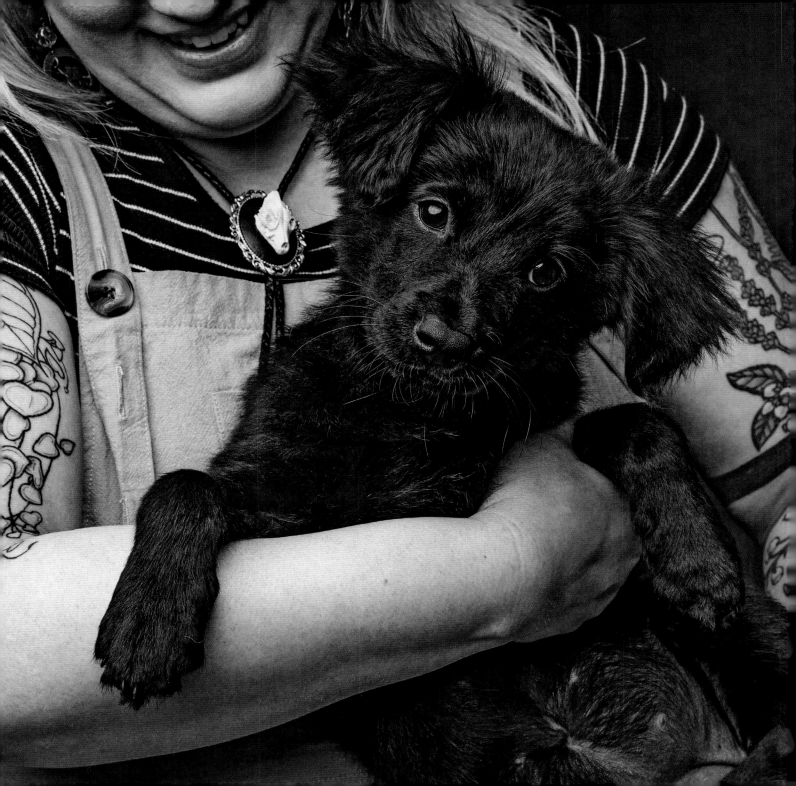

Freya

BEAGLE, PIT BULL, GERMAN SHEPHERD, SHELTIE, AND CHOW CHOW MIX

DOES SHE HAVE ANY NICKNAMES?
Goth Pup and Boo Thang

TELL US ABOUT GOTCHA DAY.
She was the tiniest pup at the SPCA and kind to and gentle with my kids. You could feel the enormous heart she had. It took some time to convince my husband, but once he met her, he was in love.

WHAT ARE HER FAVORITE THINGS TO DO?
Freya enjoys speed-walking to the point where I am practically running to keep up with her. She'll rip every last bit of stuffing out of each toy, wrestle with my son, Harrison, and snuggle with Frank, our rescue kitty.

DOES SHE HAVE ANY SILLY QUIRKS?
Being a first-time dog mom, I learned a new word: "sploot." She does not lay any other way.

She'll watch my husband clean up her toys, and when he sits back down, she'll go right on over and take them all back out. The entire family cracks up every time.

WHAT DOES SHE MEAN TO YOU?
She is my shadow. She is what I didn't know I was missing in my life until she joined it. She constantly has a smile. I have never seen an animal with such a giant heart. I honestly couldn't even think of my life without her.

—Lindsey

DOES HE HAVE ANY NICKNAMES?

Hoover, after the vacuum cleaner—he eats everything outside! Sticks and acorns are his favorite.

TELL US ABOUT GOTCHA DAY.

My sister runs a shelter in Tampa, Florida. I said to her one day, "I don't know if you ever get golden retrievers, but Ben is almost twelve, and I wouldn't mind getting another dog—but not a puppy, definitely not a puppy." Not twenty-four hours later she called and asked me, "Guess what's in my back seat?"

Yes, it was a puppy—a four-month-old golden a family had turned in because they didn't want to deal with his sensitive tummy. It took two months until I could meet my sister to pick him up.

My sister had tragically lost her son, Peter, earlier that year, and I asked her if she would mind if I named him after her son . . . and the rest is history. He has taught us all that even in the darkest of times, there is brightness.

WHAT ARE HIS FAVORITE THINGS TO DO?

We love to walk with his older brother, Ben, visiting new neighborhoods—so it never gets old! Wrestling with Ben is at the top of his list for fun, followed by searching for critters in the yard.

DOES HE HAVE ANY SILLY QUIRKS?

He is the kid at school everyone likes. He is happy-go-lucky, often invading others' space whether they like it or not. I've never heard or seen him growl or have any negative emotions.

WHAT DOES HE MEAN TO YOU?

Everything. Peter came into our life unexpectedly, and now we cannot imagine life without him.

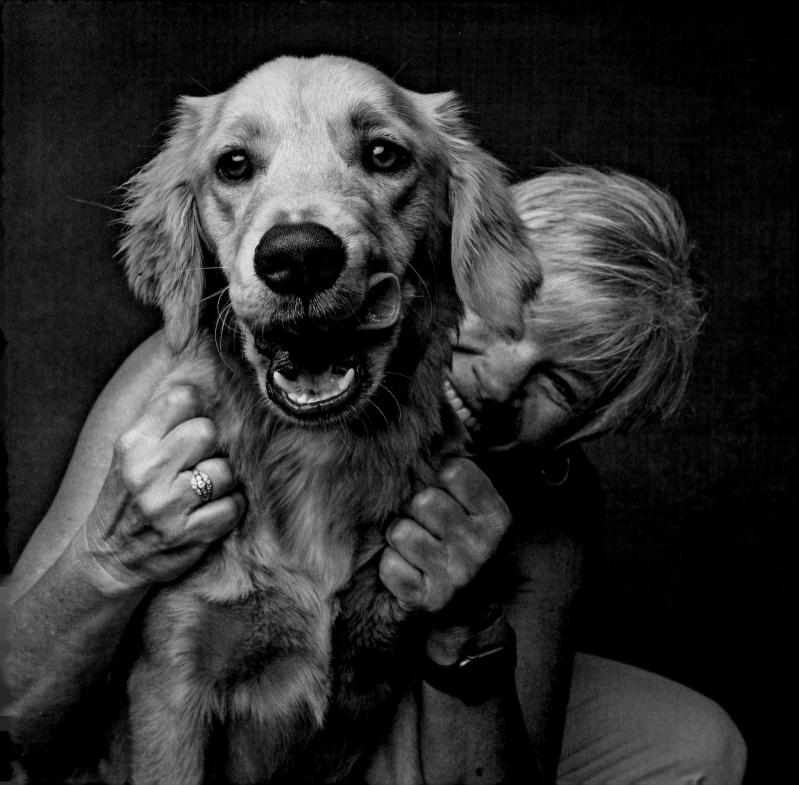

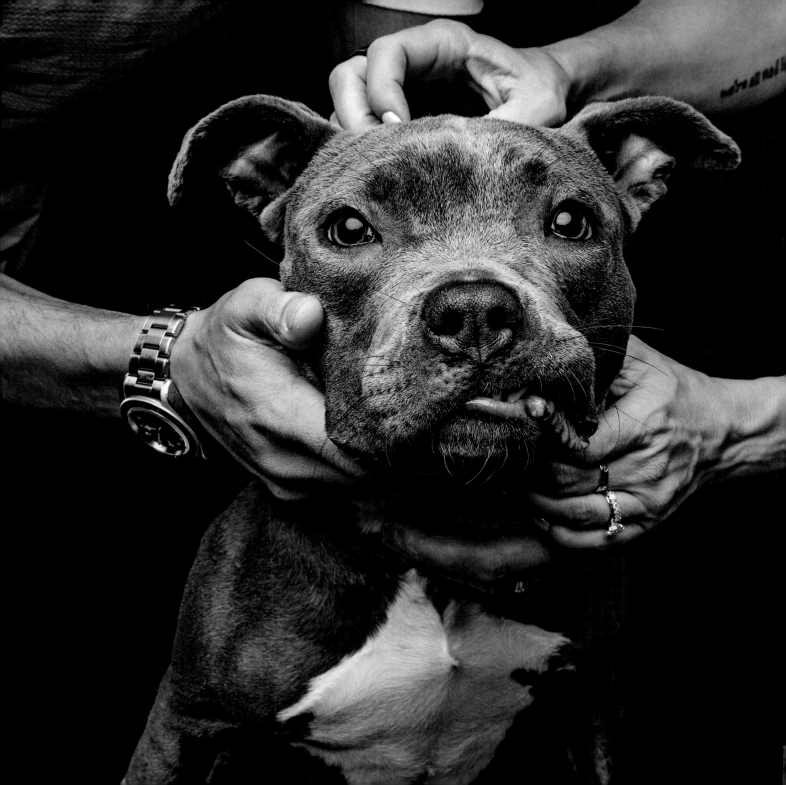

Billie

| STAFFORDSHIRE BULL
| TERRIER, 9 MONTHS

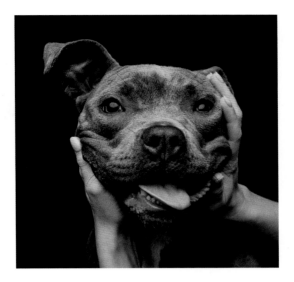

DOES SHE HAVE ANY NICKNAMES?
Silly Billie

TELL US ABOUT GOTCHA DAY.
We'd been looking for a second pit bull pup
to adopt, and when we saw Billie online and
heard her story, we immediately fell in love. She had been thrown away in a plastic
bag and left for dead. Someone, thank goodness, spotted the bag and brought her
to a shelter. From the very first meeting, we knew she was spunky! She's a jumper
and a climber!

WHAT ARE HER FAVORITE THINGS TO DO?
Billie loves to snuggle up on the couch, play with her sister, Charlee, and drink
water—she loves water.

DOES SHE HAVE ANY SILLY QUIRKS?
Due to a head trauma and malnutrition from before she was found, Billie is missing a
third of her teeth. This gives her a prominent snaggletooth. The more tired she gets,
the more her tongue hangs out.

WHAT DOES SHE MEAN TO YOU?
"One man's trash is another man's treasure." Billie has been a true treasure to us.
I never thought we'd get a dog with more personality than our first dog, Charlee.
Billie is hysterical, spunky, and maybe our favorite quality is that she is just so sweet.
It never ceases to amaze me how animals can go through so much and still have so
much love and trust to give.

—Alexandria

99

Samson

PIT BULL, AMERICAN BULLDOG, AMERICAN
STAFFORDSHIRE TERRIER MIX, 2 YEARS OLD

DOES HE HAVE ANY NICKNAMES?

Sam, Mr. Brindle Pit, Mr. BP, Slam, Slam Shady, Baby Dog, Baby Boy

TELL US ABOUT GOTCHA DAY.

Samson 100 percent chose Kevin. He was the third dog we met at the rescue, and he walked right out, sat at Kevin's feet, and proceeded to lick his whole face from ear to ear. I knew he was going to be our dog immediately because of that. Then he came over to me and gently licked my hand. He was very charming.

WHAT ARE HIS FAVORITE THINGS TO DO?

Sam loves running around with other dogs and showing off how fast he is. He loves going on long sniffari hikes with Mom, wading through rivers, playing fetch with Dad, snuggling (and being a total bed hog), and trying new foods. He's very food motivated.

DOES HE HAVE ANY SILLY QUIRKS?

Sam is incredibly dramatic. He huffs when he isn't getting enough attention. His entire body wiggles when he sees people, and he loves greeting us at the door by going "under the bridge" (shoving himself between our legs). He has really expressive eyes. He blows spit bubbles when he's impatiently waiting for food. When he sleeps, his cheeks flap. It's my favorite sound in the whole world.

WHAT DOES HE MEAN TO YOU?

I have really bad anxiety, and Samson is my emotional support animal. He takes his job very seriously. He's great at calming me down. When I'm on the verge of a panic attack or upset, he becomes an eighty-pound weighted blanket. He'll just lay across my lap until I calm down. He's very in tune with his people's emotions. Sam is my best friend and my whole world. I'd be lost without him.

—Amber

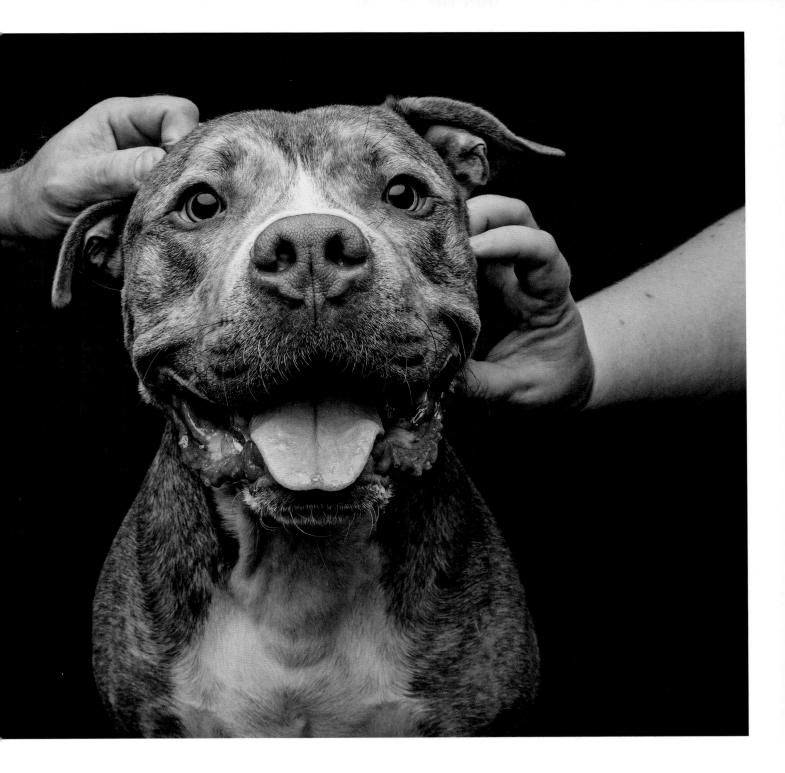

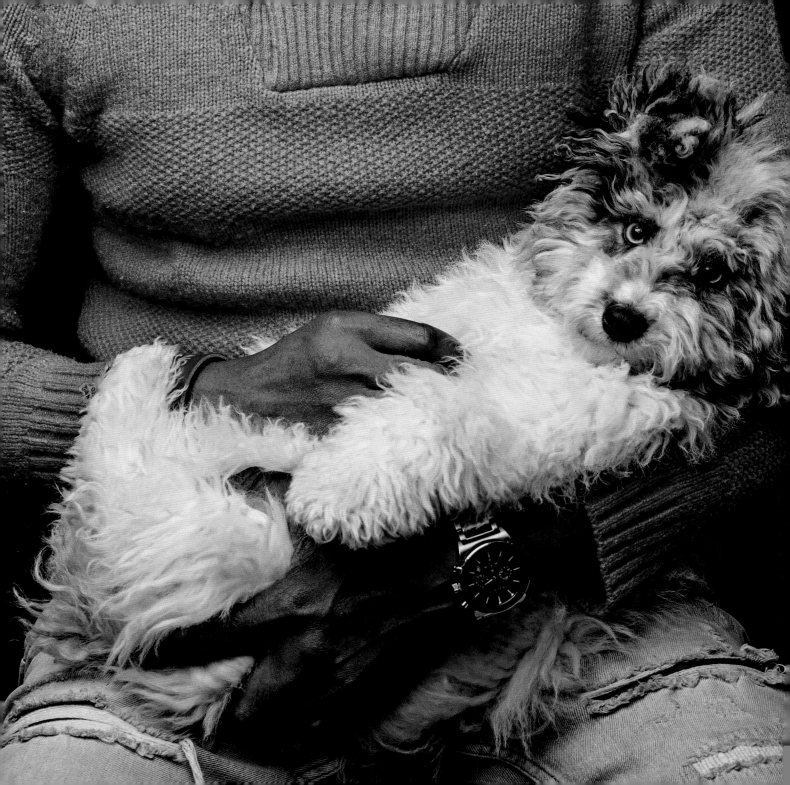

Pepper

| MINI SHEEPADOODLE, 5 MONTHS

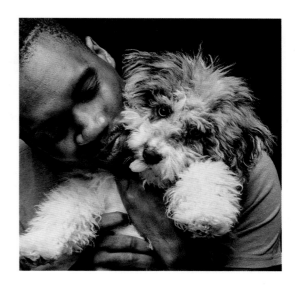

DOES HE HAVE ANY NICKNAMES?
Handsome

TELL US ABOUT GOTCHA DAY.
As a meteorologist, he reminded me of a puffy, classic cumulus cloud: cute, bouncy, and lovable. I like to think Pepper chose me when we met. I walked into the green room at 3News when he was there with his sister, Galaxy for a pet adoption segment. I learned in a short time that we have the same birthday and that he was a doodle mix, which I've always wanted. His name was one that my dad had always loved and had recommended should I ever become a doggy daddy. It was meant to be!

WHAT ARE HIS FAVORITE THINGS TO DO?
Pepper loves to play fetch with a tennis ball, toss around his toy mice and spider, give kisses and cuddles, and run and jump, especially in piles of leaves.

DOES HE HAVE ANY SILLY QUIRKS?
He can't understand that his reflection, indeed, belongs to him. He becomes intrigued and angry. He loves to wrestle. He's cute and cuddly but can be aggressive if outdone in a wrestling match!

WHAT DOES HE MEAN TO YOU?
The world.

—*Jason*

"He reminded me a puffy, classic cumulus cloud: cute, bouncy, and lovable."

Daisy

| PIT BULL, GERMAN SHORTHAIRED POINTER, AND LABRADOR MIX, ABOUT 6 MONTHS OLD

DOES SHE HAVE ANY NICKNAMES?

Lazy Daisy, Crazy Daisy

TELL US ABOUT GOTCHA DAY.

I went to the shelter with another puppy in mind. Then I saw Daisy's kennel alone in the window. She was quiet and sleeping, unlike the rest of the excited pups. She awoke quickly and made her way to the front of the crate to say hi. When I picked her up, she immediately snuggled into my neck. She was like a warm hug, and I couldn't say no.

WHAT ARE HER FAVORITE THINGS TO DO?

Roughhousing with her older sibling, Reese, and snuggling on the lap of her humans are her favorites!

DOES SHE HAVE ANY SILLY QUIRKS?

She jumps excitedly when it's time to eat—like she is on a trampoline.

WHAT DOES SHE MEAN TO YOU?

She is pure comfort when you need a hug and pure excitement when you need to laugh.

—Tana

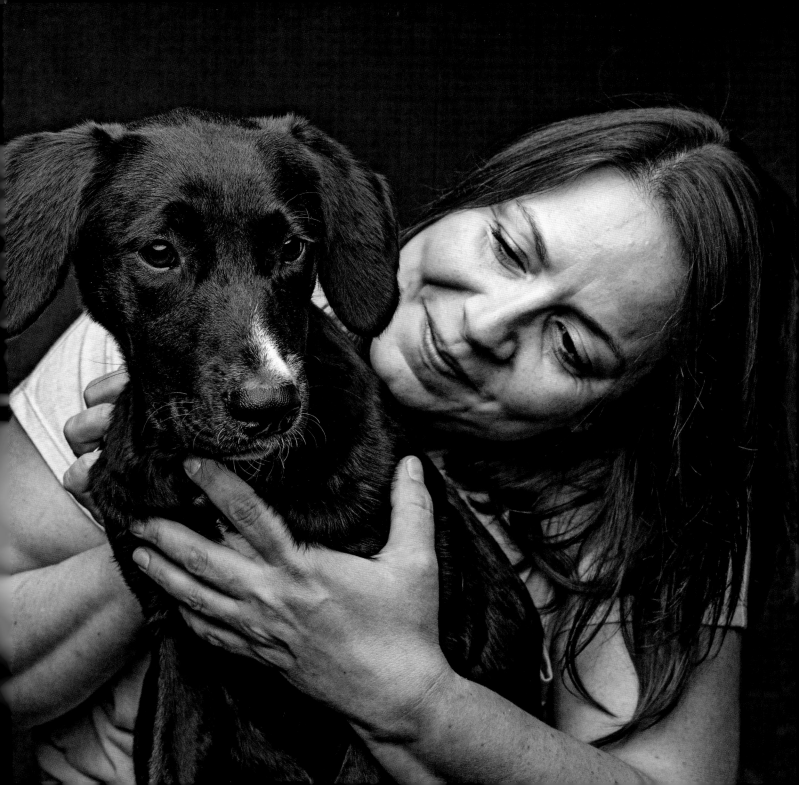

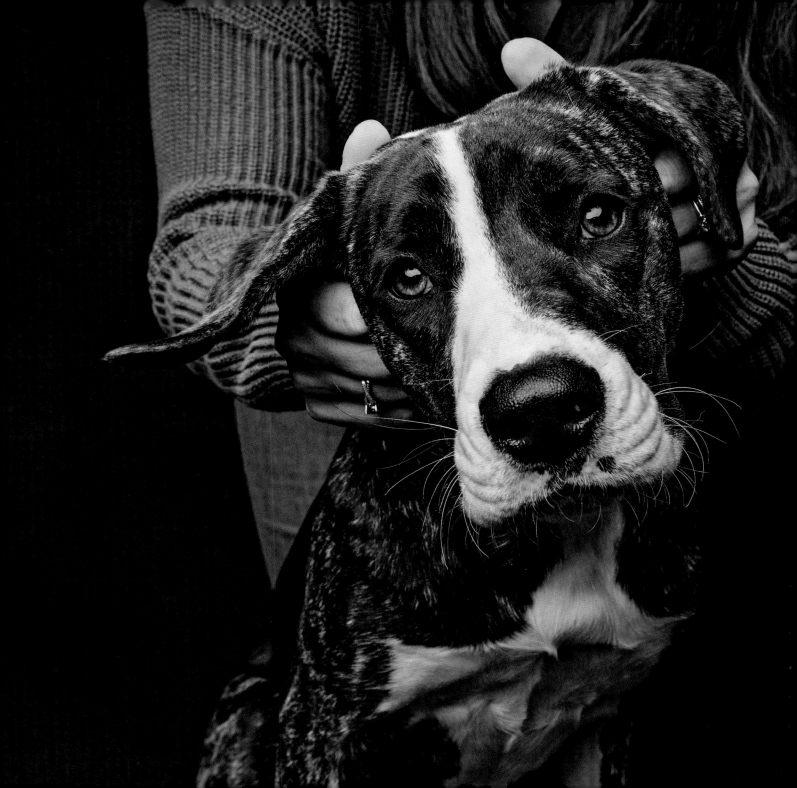

Ember

MIXED BREED, ABOUT 10 MONTHS OLD

DOES SHE HAVE ANY NICKNAMES?
Pony Girl, Swirly Girly, Miss Priss, and Ratty Girl

TELL US ABOUT GOTCHA DAY.
I was working with another dog at the rescue and saw animal control bring in a litter of six large puppies. The puppies had been dumped in the city, fending for themselves outside. Ember and her sister had their noses sticking through the kennel bars in the back of the truck. I thought they were adorable, but we weren't really looking for another dog at the time.

The next day, I went back to the shelter to walk dogs and saw the litter of puppies playing in the yard. All of the puppies were running around and playing, but Ember just walked over and curled up in my lap. She fell sound asleep, and I could tell that it was the first time she had felt safe and relaxed in a very long time. She needed a foster for the night, so I brought her home and slept on the couch with her. She did great with our other dog and our senior cat. My husband and our five-year-old son fell in love with her, too. She was supposed to go back to the shelter the next morning, but she never left our home.

WHAT ARE HER FAVORITE THINGS TO DO?
Ember loves to snuggle. She loves to go on walks, get Pup Cups at Starbucks, and attend her manners class at Cold Nose Companions.

DOES SHE HAVE ANY SILLY QUIRKS?
Ember loves to chew her toys while lying upside down. Sometimes the senior cat steals Ember's bed. Rather than push him out, she will just curl herself up very tightly to fit in the cat's bed.

WHAT DOES SHE MEAN TO YOU?
I lost my heart dog, Cole, very suddenly in March 2022. My husband and I had gotten Cole while we were in college and basically grew up with him for fifteen wonderful years. He was the best boy in the world, and losing him left a huge void in our lives. We weren't looking for another dog, but we like to believe that Cole knew we needed Ember as much as she needed us.

—*Kassi*

Rubi

PIT BULL, ROTTWEILER, AND DOBERMAN MIX, ABOUT 1 YEAR OLD

DOES SHE HAVE ANY NICKNAMES?
Rubes, Rubesicle, Rubi Tuesday, Rubi-Dooby-Doo, Baby Shark, Hambone, Spatchcock

TELL US ABOUT GOTCHA DAY.
We had wanted a dog for a long time, but when we were finally ready, it was incredibly difficult to find a puppy. The puppy market seemed as competitive as the housing market! However, we found little Rubi at PetFinder.com. She was this tiny little black potato with only one eye. Her surgery was recent enough that she still had visible stitches in her photo. It killed me to think no one wanted a physically challenged pup!

For our first meeting, she came to our house. She scared us a bit when she seemed to find every tiny mushroom in our yard! We had to do quite a bit of mushroom maintenance afterward. We gave her a little pizza cookie, played, and immediately fell in love.

WHAT ARE HER FAVORITE THINGS TO DO?
Rubi loves hiking, playing Frisbee and soccer, and roughhousing with her friends at the dog park, where she loves to flop around, do doggy somersaults as a defensive maneuver when she's playing, and frolic in the snow.

Once she burns all her energy, cuddling together on the couch is a must!

DOES SHE HAVE ANY SILLY QUIRKS?
She's very vocal and communicates her feelings well. When we ask her how her day was, she says "Ruff." We can have her "say" anything: For example, if we want her to say "I love you," we'll tell her, "Rubi, say 'I love you,'" and put up three fingers for the three syllables, to which she'll give three barks!

continued ▶▶

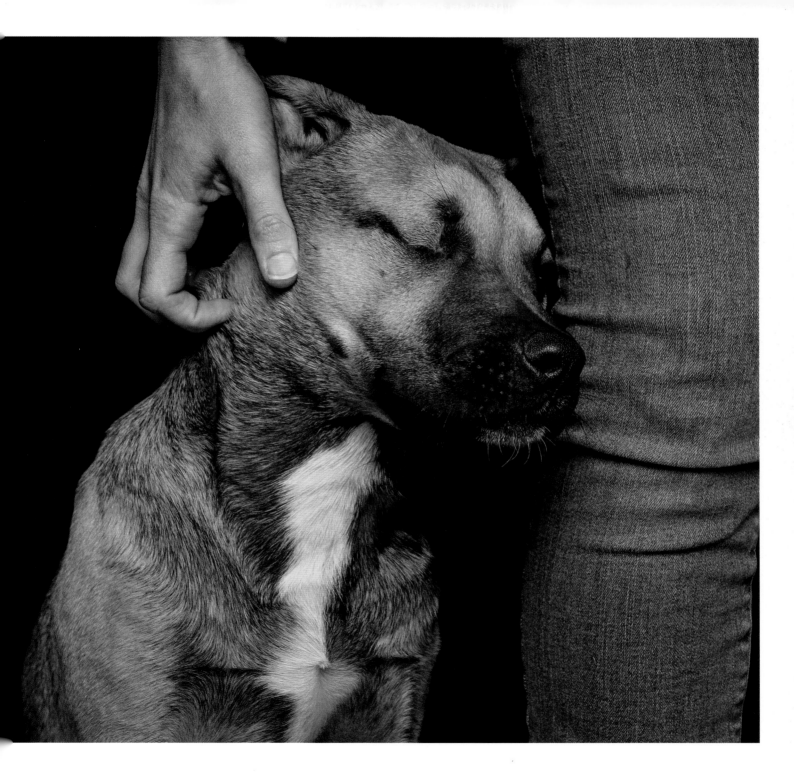

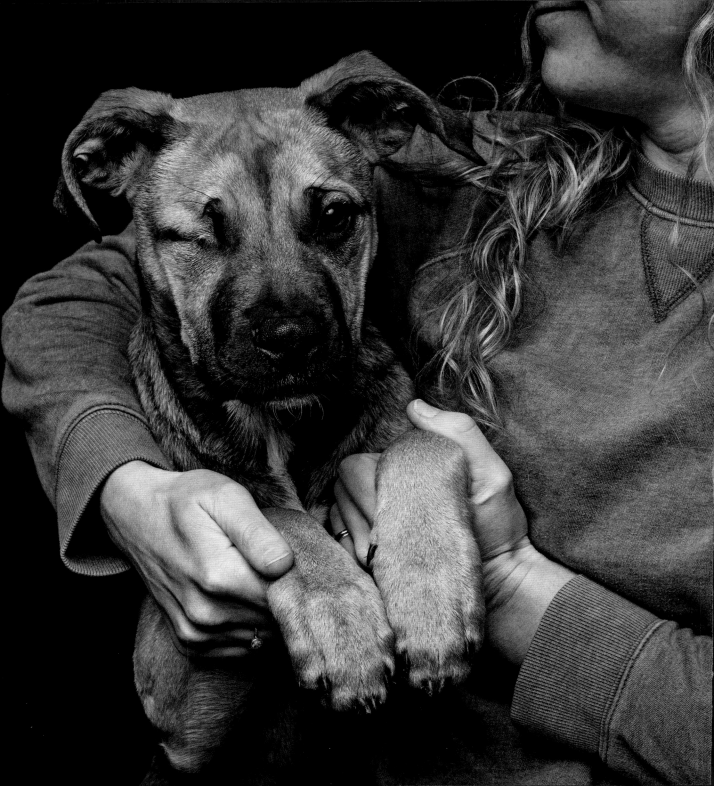

WHAT DOES SHE MEAN TO YOU?

We joke that she is our "dogter" (dog daughter), but she truly is a family member, and we love her dearly. She makes us laugh every day, keeps us healthy through our many walks together, and is incredibly loving and playful.

ANYTHING ELSE WE SHOULD KNOW?

Having one eye doesn't slow Rubi down a bit when it comes to weaving in and out of trees chasing her doggy friends. Just don't throw a toy at her—that's when her lack of depth perception kicks in, and the toy will hit her squarely in the face.

Some people think that a pit bull, Doberman, and rottweiler mix is the trifecta of aggressive dogs. In truth, we've never had a more loyal, loving, sweet, and well-behaved dog. She adores kids, and her only form of aggression is giving you all the kisses whether you want them or not. Part of her good behavior is from training, but most of it is just her sweet disposition.

—Tessa

"We've never had a more loyal, loving,
sweet, and well-behaved dog."

Hippo

| PIT BULL, 4 YEARS OLD

DOES SHE HAVE ANY NICKNAMES?
Hips, Hips Hips Bo Bips, Bubby

TELL US ABOUT GOTCHA DAY.
Hippo started as a medical foster, but I quickly fell in love with her. When I first brought her home, she went to each room and checked everything out, then jumped on the couch and laid down like she had been living there her entire life. She fit right in and adapted quickly—even with my crazy work schedule. Hippo is so sweet and calm, and it was hard to not fall in love with her.

WHAT ARE HER FAVORITE THINGS TO DO?
She loves car rides and meeting new people. She is also very fond of Pup Cups from Dunkin'.

DOES SHE HAVE ANY SILLY QUIRKS?
Hippo doesn't bark much, but she does make a cooing sound when she is happy. Sometimes when she lays flat on her stomach, she does the splits, with one leg forward and the other back.

WHAT DOES SHE MEAN TO YOU?
I lost my last dog, Clover, to cancer at the beginning of 2022. Then a month later lost my cat. I knew that I wanted to foster dogs, and Hippo was the first one. My friends said, "You know you don't have to adopt the first one you get," but of course, I didn't listen to them.

When I brought Hippo to the vet for checkups, one vet tech said, "I think Clover brought Hippo to you." We had formed a bond pretty quickly, and I think she was right. She shows me joy and makes me smile every time I see her. She helps me have a better day, every day. Hippo is unconditional love.

ANYTHING ELSE WE SHOULD KNOW?
"Love" is a four-legged word. Don't ever be afraid to adopt a bully. Hippo is a huge sweetheart, and everyone who meets her loves her.

—Jaime

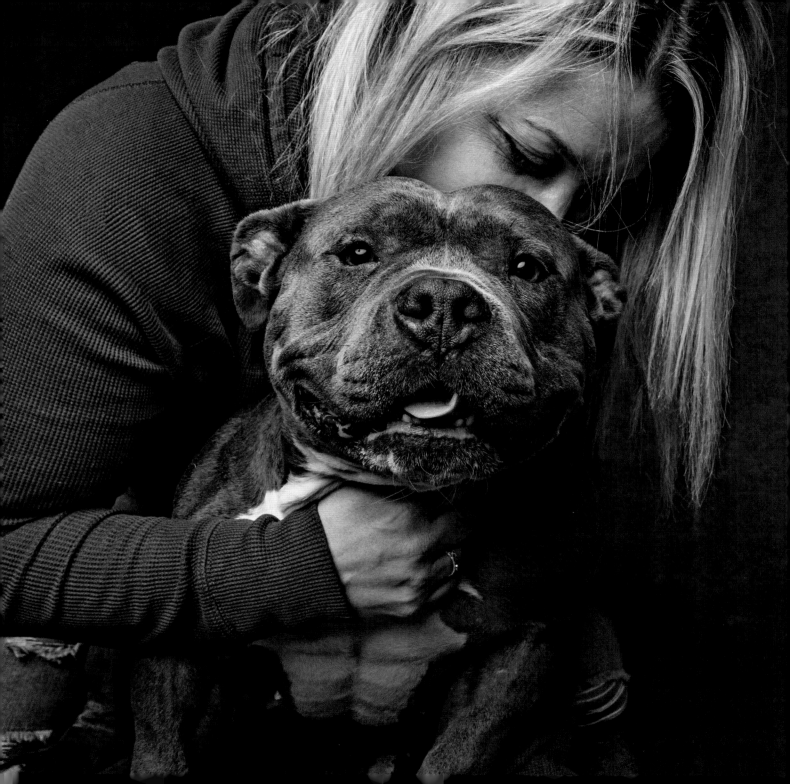

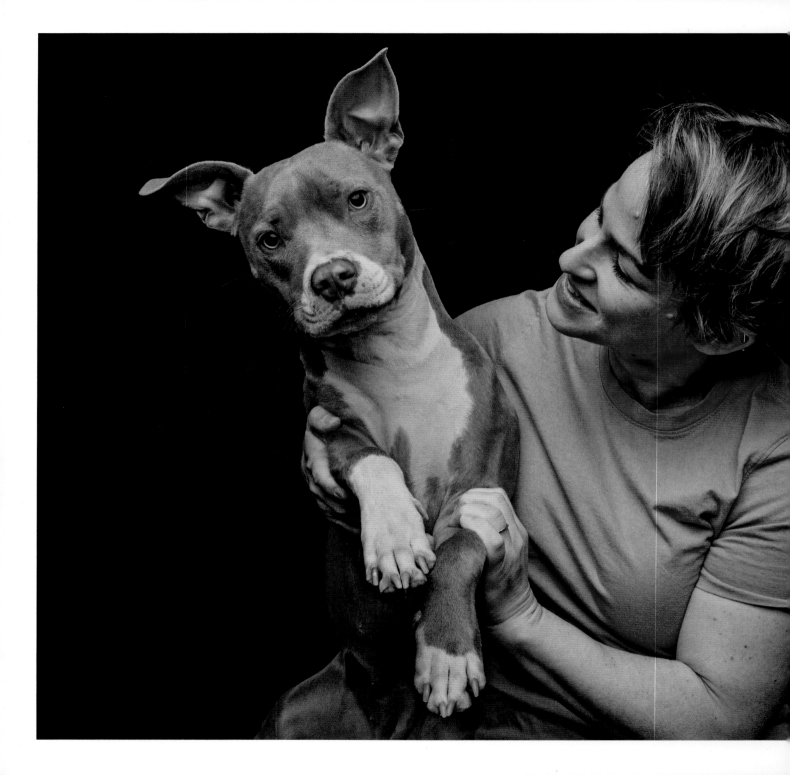

Holly

| PIT BULL AND WHIPPET MIX, ABOUT 1 YEAR OLD

DOES SHE HAVE ANY NICKNAMES?
Hox, Squid, Small Fry, and Gerbs (as in gerbil)

TELL US ABOUT GOTCHA DAY.
After we lost our previous rescue pittie, Thea, to lymphoma in May 2021, we were looking for another little nugget to share our lives. We had rescued Thea when she was about three months old and had her until she was almost fourteen. We had a gaping hole in our hearts after we lost her. We wanted another puppy or young dog, and we wanted to support rescue.

Holly was born with her littermates to a stray pittie mama named Harper, who was picked up by the rescue. (Harper went on to nurse other litters that didn't have mamas—she was pure love with huge ears.) When we went to meet them, there were four pups left. We were told that Holly didn't like to be held, but she jumped right into my lap—and that is still her very favorite place to be.

WHAT ARE HER FAVORITE THINGS TO DO?
Any type of playing! She loves to roughhouse and play fetch and keep-away. She loves all her toys equally, but her favorites are small ones the size of cat toys. She *loves* to cuddle. We call it Velcro (as in "Holly, do you want to Velcro?"). She is the most Velcro dog we have ever met. She also loves car rides, going to Grandma's house, and traveling and staying in hotels!

DOES SHE HAVE ANY SILLY QUIRKS?
Holly is a "Woo!" girl. She is very vocal when she is excited or just has something on her mind. She lets us know that she wants to play or that she is not completely angry with us when we get back from being away or get out of the shower.

continued ▶▶

WHAT DOES SHE MEAN TO YOU?

She is more than family—she is our lives. Giving her a good life makes our own lives better and more whole. She brings so much happiness, laughter, and love to us, and we hope that everyone can experience this type of pure love at least once in their lives.

ANYTHING ELSE WE SHOULD KNOW?

We *think* she is a pit bull and whippet mix, so we call her a "pippet," but we really have no clue. Our guess is not based on actual facts . . . but we don't care what she is!

—*Valerie*

"Giving her a good life makes our own lives better and more whole."

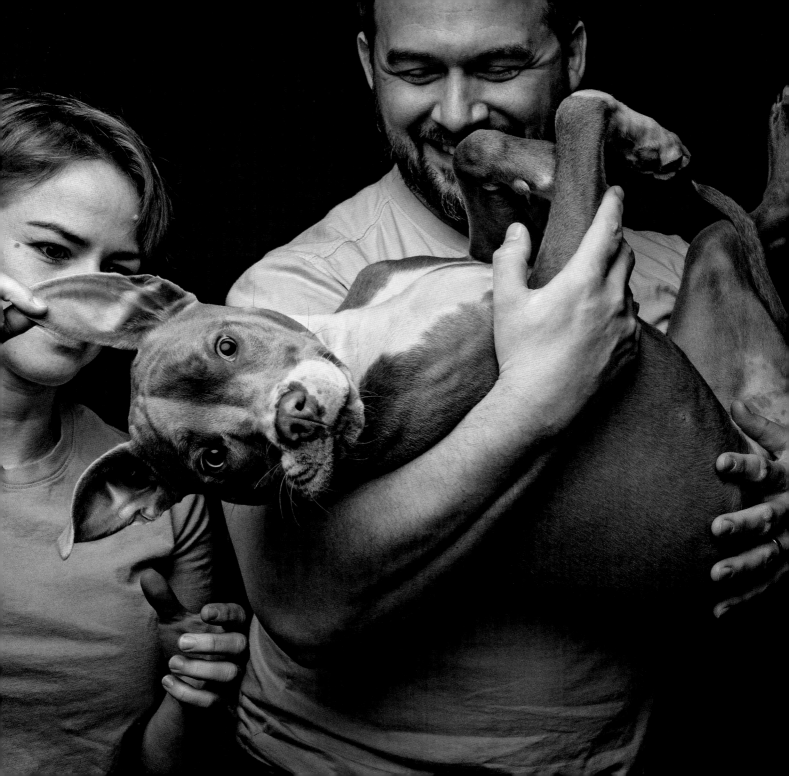

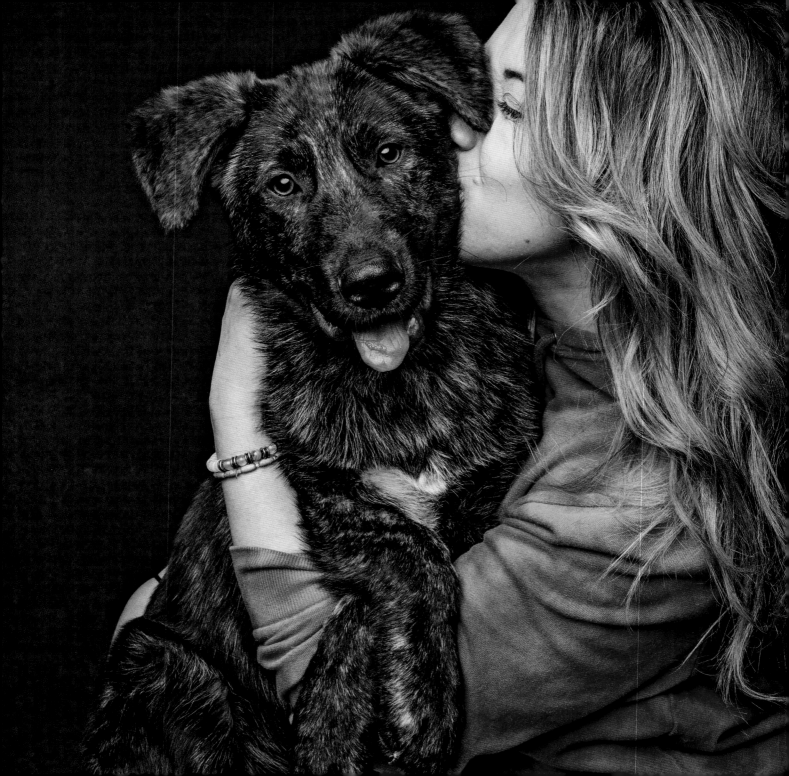

Floyd

| MIXED BREED, 1 YEAR OLD

DOES HE HAVE ANY NICKNAMES?
We mostly call him Mister and Sir, which are ironically distinguished nicknames for a giant goofball.

WHAT ARE HIS FAVORITE THINGS TO DO?
Floyd is a living embodiment of adventure, excitement, and a lust for life. He comes everywhere with us and has been hiking, backcountry camping, kayaking, swimming, and road tripping. From festivals and fairs to parties and parades, he's been everywhere—from the city to the country. Never far from our side, he is always close behind when we do chores or yardwork (a shadow that's also a tripping hazard!), contentedly snoozing on the couch when I'm working from home, and ready to go whenever an adventure beckons.

Floyd loves everyone he meets, humans and creatures alike, and he greets every situation and new friend with infectious gusto and enthusiasm. He is the perfect companion for our active lifestyle and truly epitomizes the term "adventure dog."

DOES HE HAVE ANY SILLY QUIRKS?
No matter where we go, Floyd is always on the hunt for the biggest and most impressive stick he can get his paws on, even if it means breaking off a fresh one from a bush or tree. Although he'll settle for a twig if there's nothing else around, he will continuously search until he finds the "best" one in the area. Whenever Floyd has a toy or a stick, he struts proudly with it, his whole body swaying back and forth in sync with his steps.

When he wants to show you affection, Floyd will grab your entire arm with his mouth and hold it gently. If you kneel to his level, he will stand up on his haunches and wrap his front paws around your arm or neck for a hug.

WHAT DOES HE MEAN TO YOU?
Anyone who has ever had the fortune of loving a dog can relate to the unique bond it creates; Floyd is no exception. He is our steadfast companion, an intrepid explorer, my de facto coworker, and occasionally my sounding board and confidant. His presence is always a source of joy and comfort, no matter how stressful the day may have been. He is nearly one hundred pounds of pure joy and unconditional love and truly a part of our family.

—*Jessica and Ryan*

Blue

| STAFFORDSHIRE BULL TERRIER, 2 YEARS OLD

DOES SHE HAVE ANY NICKNAMES?
Bluey, Bluest, Miss Blue, Blue-Girl

TELL US ABOUT GOTCHA DAY.
Once our daughter, Missy, got her blue pittie, Joker, I wanted a blue pocket pittie (a mix of an American pit bull terrier and Patterdale terrier). I saw Blue's pictures at one in the morning and applied immediately to the Ross County Humane Society to adopt her. I cried when we were selected! Blue was rescued from a bad situation. She had been locked in a cage without food or water for days. But this didn't take away her ability to love us one bit! We had a chance to foster first, but no, we knew at first sight, first touch, first hug, she was coming *home* with us.

WHAT ARE HER FAVORITE THINGS TO DO?
On the *best* dog day you'll find Miss Blue running zoomies around Mommy in the backyard, playing fetch, and chasing squirrels. She loves car rides and is a great traveler! She especially loves camping "in her house," which is under the table inside our camper.

DOES SHE HAVE ANY SILLY QUIRKS?
Often you will find Blue proving she's not too big to be a lap dog by squishing in next to Daddy on the recliner or laying on his lap or across his shoulders.

WHAT DOES SHE MEAN TO YOU?
My husband, Jack, who didn't initially want another dog, now says, "She brings me joy. Makes me happy when she is so excited to see me when I get home." Even though he is currently cancer-free, Jack will always spend a few hours a day in his recliner, with a G-tube and liquid diet. But sure enough, Blue is right next to him, making the whole experience a little better.

—Suzanne

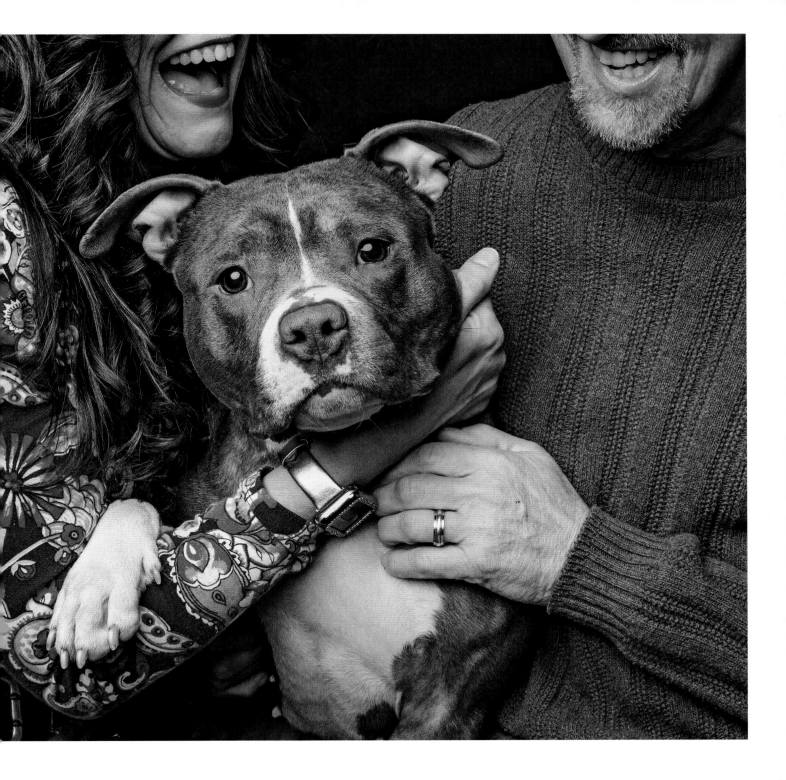

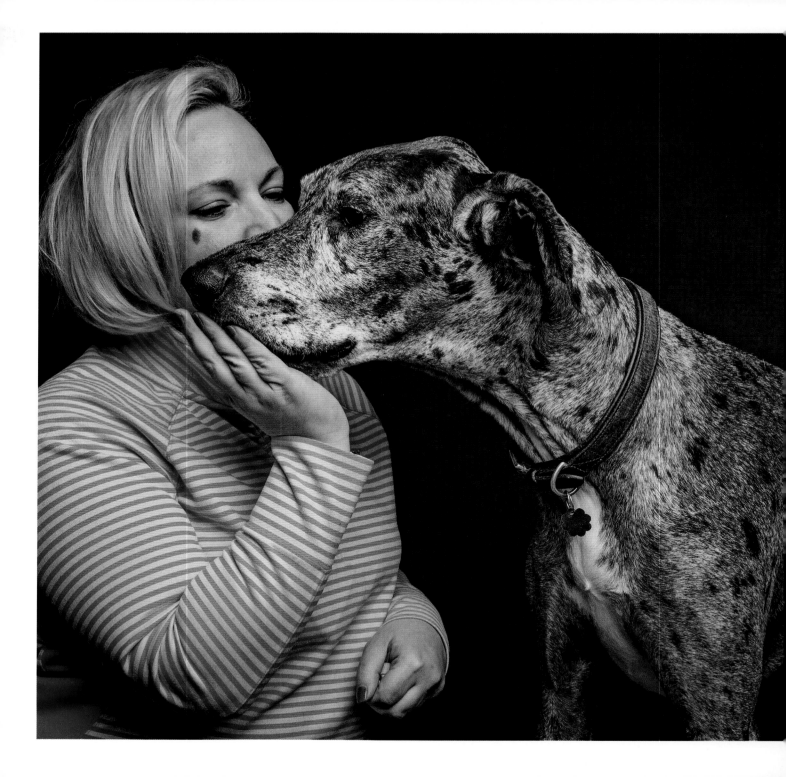

Maverick

| GREAT DANE, 5 YEARS OLD

TELL US ABOUT GOTCHA DAY.

When I met him for the first time, Maverick was tied to a tree on a hot summer day with no water and very little shade. He was very thin, almost manic, and probably hadn't slept. The family I rescued him from had kept him tied to that tree for a week after buying him on Facebook Marketplace and then deciding he was too big for their small house. I could tell he was scared even though he was acting so ferocious, and I knew he wouldn't be safe with anyone but me.

He jumped in my car before I had a chance to open the door all the way. He hasn't left my side since.

WHAT ARE HIS FAVORITE THINGS TO DO?

Sleeping, exploring the woods, car rides, playing with toys, and doing yoga with me. (He mirrors my movements!)

DOES HE HAVE ANY SILLY QUIRKS?

Maverick sits on the couch like a human—with his butt on the seat and his front legs on the ground. He acts like it's totally normal!

WHAT DOES HE MEAN TO YOU?

My dog means everything to me. When I rescued him, I was going through a lot of PTSD related to domestic violence and sexual assault. I didn't rescue Maverick because I needed him to help me learn how to be patient with myself through my own healing process, but that's how it's worked out. Maverick's history is completely unknown to me, but there was some trauma in his life at some point that made him very scared around other dogs. Due to his enormous size, it has been difficult to manage Maverick's behavior the way I would handle any other dog. He came to me with so much anxiety and fear that many people told me to put him down before he hurt someone.

continued ▶▶

Thankfully, he slowly began to trust me, and I gained confidence that I could help him. It took about a year, but he is finally a relaxed, smooshy couch potato who sleeps through just about anything.

ANYTHING ELSE WE SHOULD KNOW?
Advocating on Maverick's behalf during his rehabilitation, explaining to others that he needed time to regain confidence, that he was reacting so explosively to seemingly small things because he'd been hurt in the past with nobody to help him, and impressing on everyone the need to treat him with calm, consistent reassurance was a very important reminder that I needed those things for myself during my own recovery.

—*Mallory*

"He jumped in my car before I had a chance to open the door all the way. He hasn't left my side since."

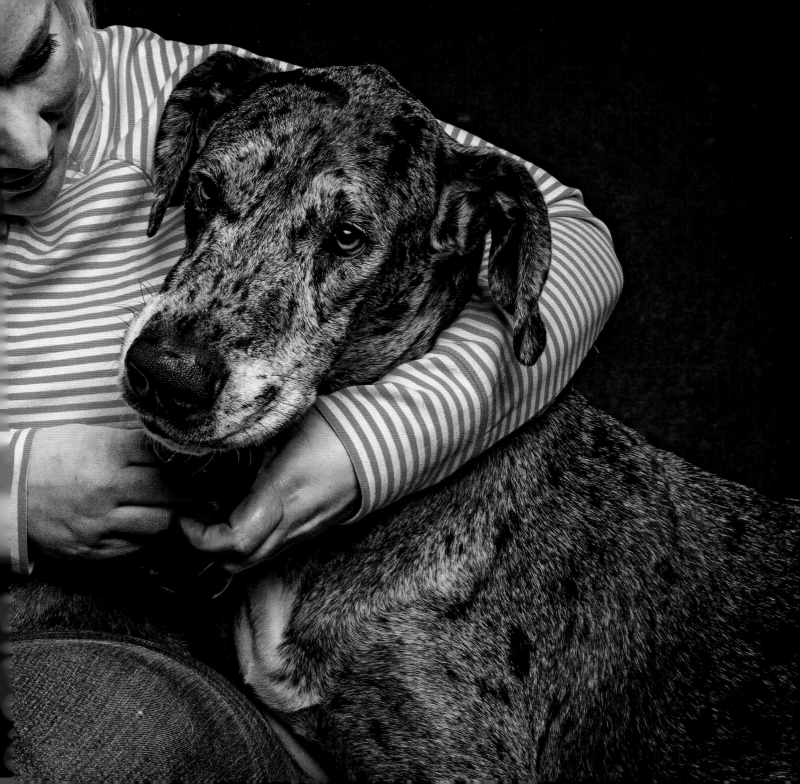

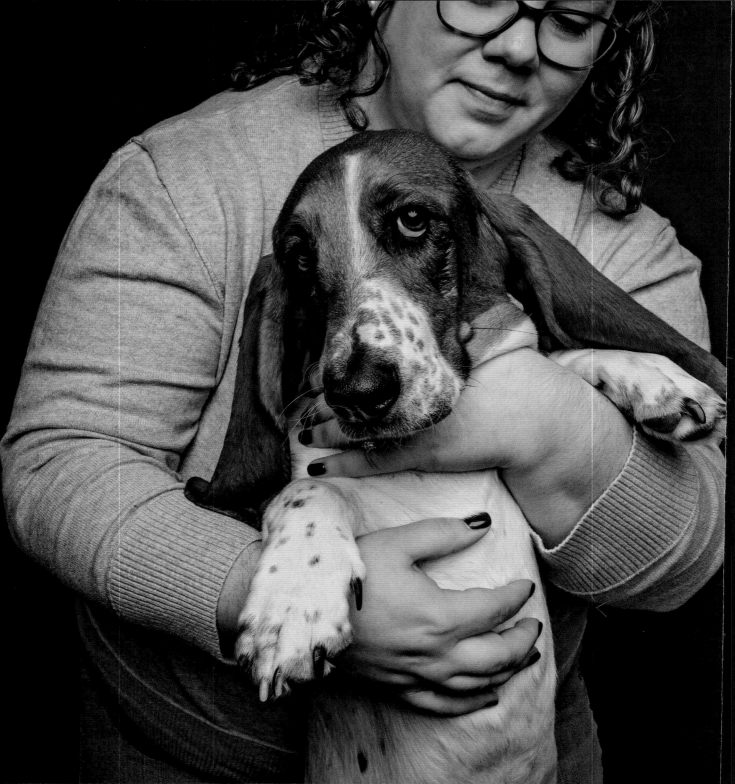

Walter

| BASSET HOUND, 9 YEARS OLD

DOES HE HAVE ANY NICKNAMES?
Walaroo, Walrus, Waldog, Perfect Boy, the Good One

TELL US ABOUT GOTCHA DAY.
Walter was just our kinda guy. We had said goodbye to our senior dogs a year before, had moved, and really needed to make the house a home. We learned that he was looking for a new house, too. The first meeting was love at first sight. He plopped down on the floor and rolled over for a belly rub, and that was it. Our house was immediately a *home*.

WHAT ARE HIS FAVORITE THINGS TO DO?
He loves belly rubs, chewing a bone outside in the sunshine, and short trail walks with good scents.

DOES HE HAVE ANY SILLY QUIRKS?
When he's really happy or excited, he swings his tail in a complete circle. He will participate in "choir practice"—if you start howling, he will join right in and take a solo.

WHAT DOES HE MEAN TO YOU?
Walter means everything. We have had the pleasure of knowing and loving many dogs in our lives, and he is by far the greatest culmination of all of them. Once, while babysitting our niece, she became inconsolable at bedtime and the only thing that would make her stop crying was knitting her fingers in Walter's fur and burying her face in his wrinkles. Not ever having had him around children we were terrified of how he would do in the situation (and very cautious), but he patiently sat and let her cry. When she finally fell asleep, he laid by her crib until her parents came home. He was a saving grace for all of us that night.

He is absolute joy, happy to join on an adventure or be a quiet confidant after a long day.

ANYTHING ELSE WE SHOULD KNOW?
Unfortunately, Walter has been recently diagnosed with lymphoma and is undergoing chemotherapy. We are fortunate that he has an incredible medical team and is an absolute rock star about his appointments. We are hoping for as much time as possible but are so grateful for any day we have with him. We know our time together will be shorter than what we wanted or imagined at our first meeting, but our days are filled with love and joy because of him.

—*Emily*

Beatrix

BASSET HOUND, 1 YEAR OLD

DOES SHE HAVE ANY NICKNAMES?
Bea, Busy Bee, "Darn It, Bea!," "What Now?!"

TELL US ABOUT GOTCHA DAY.
We were sent photos from the animal control officer who knew we loved basset hounds. Bea had a beautiful face but was skinny and emaciated. When we met her, she was shy, reserved, and smelled unwell. She needed a place to call home and some good food, and we had space on the couch and in our hearts.

WHAT ARE HER FAVORITE THINGS TO DO?
She loves to cause mayhem. She chews on anything and everything. She'll eat anything and everything. She loves going on hikes and sniffing everything. When she finally stops moving, she loves to cuddle.

DOES SHE HAVE ANY SILLY QUIRKS?
She loves to shred cardboard—recycling is not safe around her! She is learning to howl but hasn't mastered it yet.

WHAT DOES SHE MEAN TO YOU?
Beatrix is the first young dog we have had in a very long time. Right now, she means exasperation, frustration, and exhaustion. However, she has reminded us that many things (that she has chewed) are replaceable, insignificant, or trivial. Most importantly, she has reminded us that joy in the little things (like chasing lightning bugs) is everything. She is a daily reminder that life is short, so we better get busy exploring.

—*Emily*

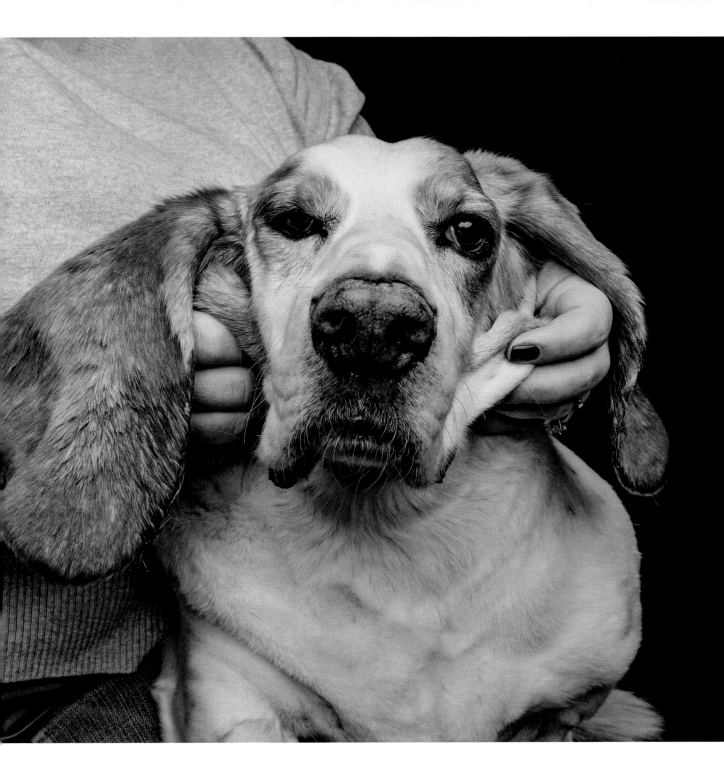

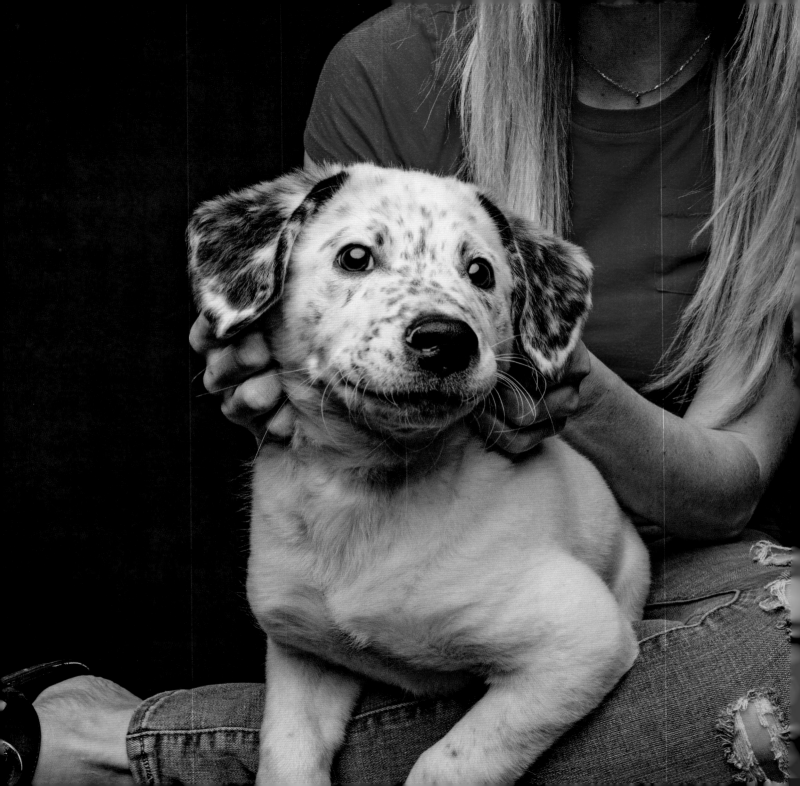

Oscar Wilde

| CATTLE DOG, AUSTRALIAN SHEPHERD, AND PIT BULL MIX, 1 YEAR OLD

DOES HE HAVE ANY NICKNAMES?

His full name is Oscar Wilde of House McCool. We also call him Oscar the Wilde Man, Handsome Prince, Buddy, Little Lover, Sweety Peetie, and My Little Turkey.

TELL US ABOUT GOTCHA DAY.

I lost my first pup, Harry Winston the puggle, and wasn't sure I'd want another dog anytime soon. But one night just shy of two months later, I was scrolling through adoptable dogs on the Cause for Canines website, and when I saw Oscar Wilde's face, I started tearing up. That's when I knew I had to help this little buddy out and take care of him.

WHAT ARE HIS FAVORITE THINGS TO DO?

Oscar Wilde loves playing tug and fetch. He loves to sit on top of the back of the couch like he's a cat! He likes to get up there when I'm sitting on the couch and rest his head on my shoulders, and it's kind of like I'm wearing him as a scarf. He also loves watching for dogs (and trying to talk to them) on TV and wrestling in the backyard with his cousin, Althea, the sweetest pit bull you'll ever meet.

DOES HE HAVE ANY SILLY QUIRKS?

Oscar is a big thumb sucker. He's done it since I first brought him home at nine weeks old, and so far at nearly a year old, it's one of the only things that will get him to sit still besides snacking on a tasty bone. He has recently taken to sitting on the toilet and trying to climb into the bathroom sink while I do my makeup, which is fun for everyone! He's a natural herder, and he's always trying to get people to go where he wants them to go. He's got *so much* energy, and he's a lot of fun to see get excited about life. He's constantly learning and is very smart—too smart for all of our own good, actually!

continued ▶▶

WHAT DOES HE MEAN TO YOU?

Oscar Wilde is the sweetest buddy, and I'm so thrilled that we found each other. Making sure he feels loved and taken care of means everything to me.

ANYTHING ELSE WE SHOULD KNOW?

When I first brought him home, we kept him in a laundry basket instead of a crate because he was small. Now he weighs more than forty-five pounds, and I swear he stands five feet tall on his hind legs! He takes advantage of those long, spindly legs too . . . because, let me tell you, Oscar Wilde is very good at being a puppy! He's peed on everything I own and has stolen the best parts of my favorite meals. And he also stole my heart. I love this little ruckus-causer and havoc-wreaker so much. I'm so thankful I get to be his mama.

—*Stephanie*

"Oscar Wilde is the sweetest buddy, and I'm so thrilled that we found each other. Making sure he feels loved and taken care of means everything to me."

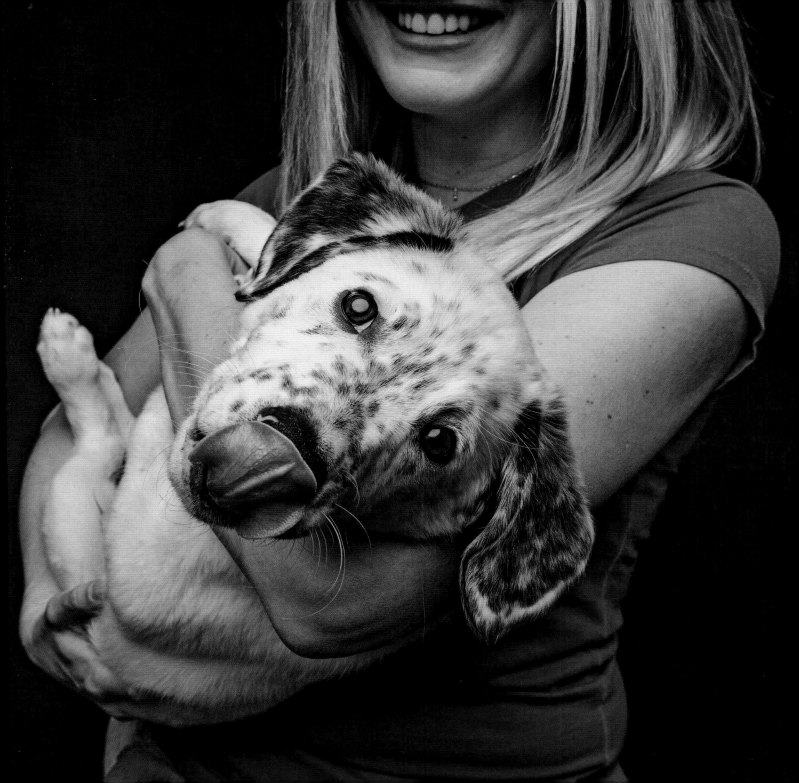

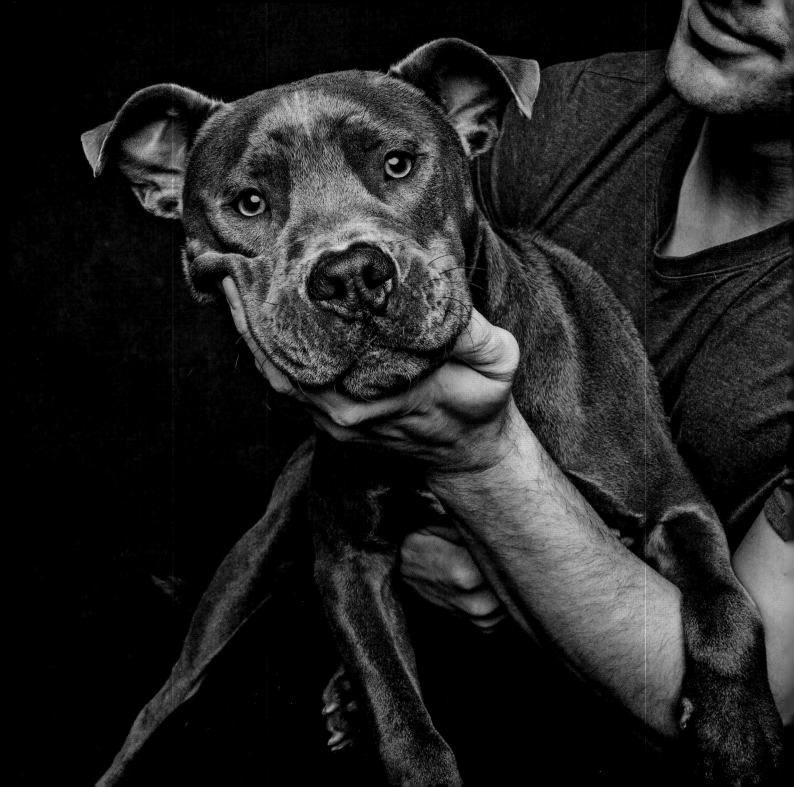

Norman

| PIT BULL MIX, 1 YEAR OLD

DOES HE HAVE ANY NICKNAMES?
Stormin' Norman, Normy

TELL US ABOUT GOTCHA DAY.
We are huge fans of pit bulls, so when I saw a
picture of this beautiful gray pit puppy, I knew
we had to meet him. We met him in his foster's
home and instantly fell in love with his pudgy belly and soft fur.

WHAT ARE HIS FAVORITE THINGS TO DO?
Norman enjoys playing fetch, going for walks, and chasing the kids around. He has
yet to grow out of his "trouble" phase, so he also enjoys chewing things and chasing
the cats! When he calms down, he snuggles up with his buddy, Elwood (page 143).

DOES HE HAVE ANY SILLY QUIRKS?
Norman is afraid of noises and the dark, so in an attempt to be tough, he barks as
loud as he can while backing up. He also is obsessed with ice. Whenever he hears
someone getting ice, he stops what he is doing and runs to the kitchen so he can
catch any ice cubes that drop on the floor.

WHAT DOES HE MEAN TO YOU?
Both of our dogs are truly part of the family. Whether we are having a movie night
or going outside to play, they are with us. They've gone to softball games and even
vacationed with us. Norman and Elwood have comforted sick or sad kids on multiple
occasions. As a family, we understand that dogs are a commitment, and we plan to
care for them through the good and the bad.

—Elizabeth

Niki

| LABRADOR RETRIEVER AND
| DALMATIAN MIX, 4 MONTHS OLD

DOES SHE HAVE ANY NICKNAMES?
Nik and Good Girl

TELL US ABOUT GOTCHA DAY.
When I met her, I felt our hearts connect,
and I just knew I would be honored to be her human.

WHAT ARE HER FAVORITE THINGS TO DO?
We love to go on long walks and love to play ball. She loves meeting new people and sits and waits for them to pet her.

DOES SHE HAVE ANY SILLY QUIRKS?
When I first brought Nik home, she wouldn't go to sleep without me holding her. She loves to sit as close to me as she can and then nuzzle her head on my shoulder and neck. When she wants Emily, our older dog, to play, she brings her a toy and rolls over to show her belly.

WHAT DOES SHE MEAN TO YOU?
She means faith in things to come. She is kind and loving, and I know she will bring joy and comfort to so many.

—Julia

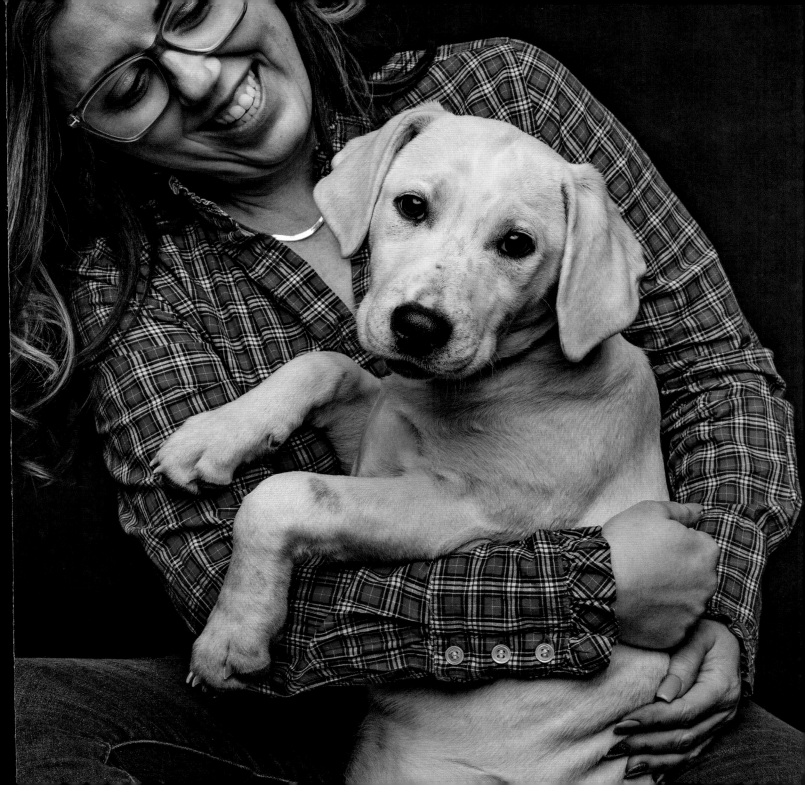

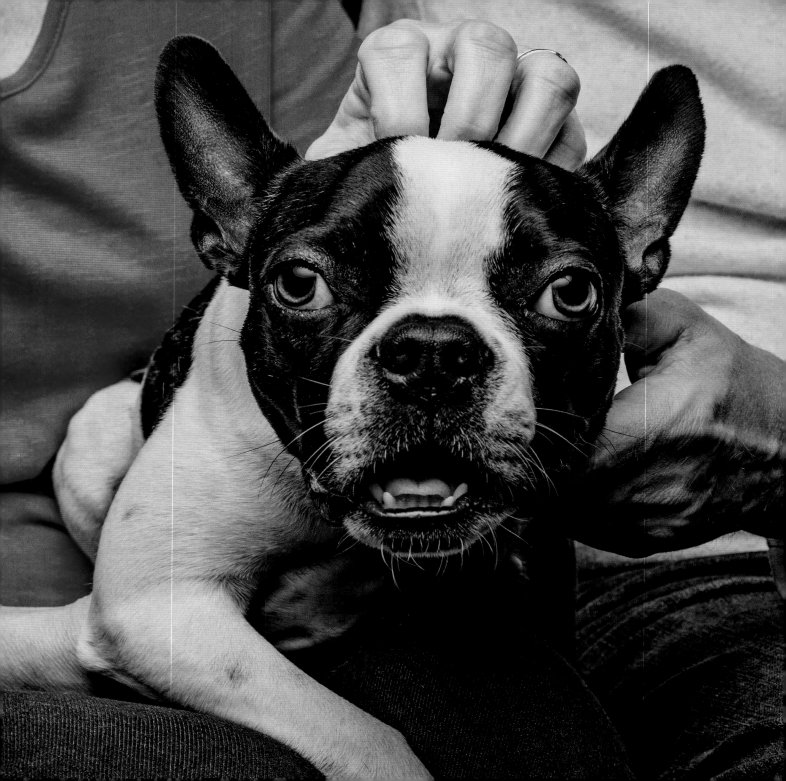

Linus

| BOSTON TERRIER, 2 YEARS OLD

DOES HE HAVE ANY NICKNAMES?
Whinus

TELL US ABOUT GOTCHA DAY.
My husband and I believe all dogs are good dogs who deserve a loving and accepting home, so before Linus we had taken in two other dogs whose owners wanted to rehome them. At our first meeting and for the first week, Linus was a little angel. Then his mischievous personality emerged and has stayed ever since.

WHAT ARE HIS FAVORITE THINGS TO DO?
Linus would like to play every hour of the day. He loves fetch, tug-of-war, and watching for chipmunks out the back door, although he has yet to catch any despite devoting his life to this mission.

DOES HE HAVE ANY SILLY QUIRKS?
He's a terrier, so he likes to burrow under the covers. He's also very vocal and whines a lot, hence his nickname.

WHAT DOES HE MEAN TO YOU?
Linus was adopted by my brother and his wife during the pandemic. He was far more active than they expected, which was more than they could handle. They were at the point where they wanted to rehome him, so we said we would take him. My brother passed away three months later, so I feel like I still have a part of him through Linus.

—Leslie

Tizzy

AMERICAN STAFFORDSHIRE TERRIER AND PIT BULL MIX

DOES SHE HAVE ANY NICKNAMES?
Beans, Beaner, Butter Bean, Beanie Boo, Wizzy, Tiz

TELL US ABOUT GOTCHA DAY.
We first saw a picture of Tizzy in an Instagram photo taken by Greg Murray. She looked sweet and a little awkward, and so we drove across town to meet her at her foster home. She was a bit shy at first, but as soon as I sat down on the floor she crawled into my lap and that was it; we knew she was our dog.

WHAT ARE HER FAVORITE THINGS TO DO?
Tizzy loves going on walks and catching her nubby, squeaky ball, or a treat—she's a great catcher! Her favorite place is Paws Cleveland, where she goes every week to play with her dog friends and the staff. In the winter, you'll find her camped out in front of our wood-burning stove, baking her belly.

DOES SHE HAVE ANY SILLY QUIRKS?
Tizzy usually comes home from daycare a bit wet. For a long time, we figured this was because she was roughhousing with other dogs, but it turns out there was another reason. They sometimes use a spray bottle when dogs do something they shouldn't. Tizzy, however, doesn't see the spray bottle as a correction; she loves to bite the water. She chases the staff around when she sees it—so they spray it at her so she can bite it!

WHAT DOES SHE MEAN TO YOU?
Tizzy truly is a member of our family. We have loved seeing her transform from an anxious, fearful doggy into a confident girl.

ANYTHING ELSE WE SHOULD KNOW?
She had a rough start in life, so she came to us with some behavioral issues as many rescues do. After the COVID-19 lockdown, we reached out to Miracle K-9, who had been recommended by a friend. She got the training she needed from them and is a much better, calmer, happier dog today.

—Doug

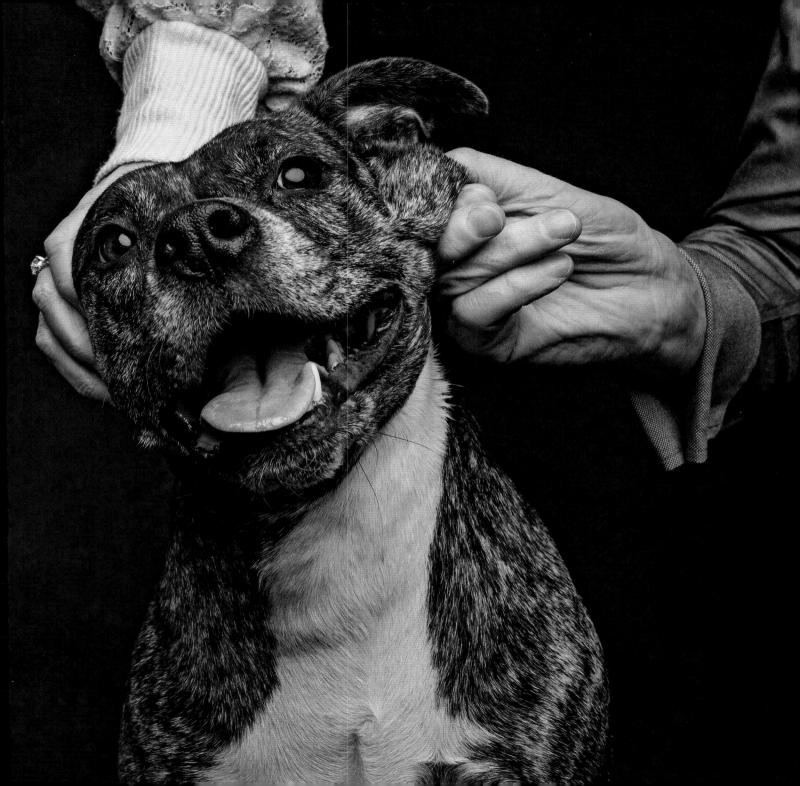

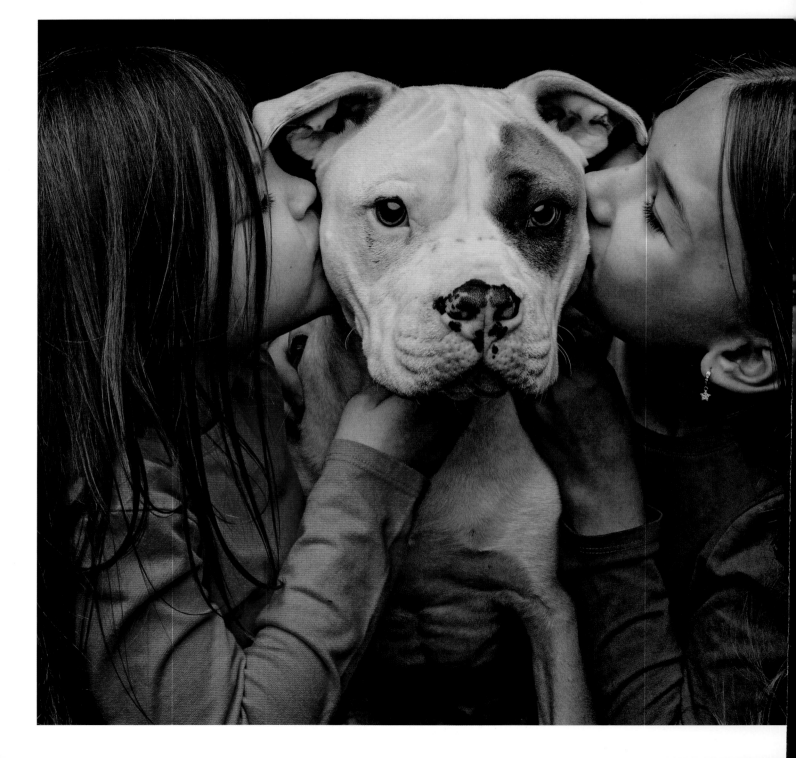

Elwood

| PIT BULL MIX, 1 YEAR OLD

DOES HE HAVE ANY NICKNAMES?
El, Elwood Blues, El El Cool Wood

TELL US ABOUT GOTCHA DAY.
Shortly after losing our two previous rescue dogs, we couldn't stand not having a dog. We love pit bulls—and we saw his picture on Petfinder. We loaded up the kids and went to pick him up. He was the cutest little piglet-looking puppy we ever saw. One of our daughters sat on the ground and he got right on her lap.

WHAT ARE HIS FAVORITE THINGS TO DO?
Elwood enjoys playing fetch, going for walks, and chasing the kids around. Like his buddy, Norman (page 135), he also enjoys chewing things and chasing the cats! When he actually calms down, he loves to snuggle, especially in a warm sunny spot.

DOES HE HAVE ANY SILLY QUIRKS?
He thinks he is a lap dog. He's over sixty pounds, and he doesn't even know it. Anyone who sits on the floor in our house better be ready for him to take a seat right in their lap.

WHAT DOES HE MEAN TO YOU?
Both of our dogs are truly part of the family. Whether we are having a movie night or going outside to play, they are with us. They've gone to softball games and even vacationed with us. Norman and Elwood have comforted sick or sad kids on multiple occasions. As a family, we understand that dogs are a commitment, and we plan to take care of them through the good and the bad.

ANYTHING ELSE WE SHOULD KNOW?
He's big, clumsy goof. When he gets silly and playful, he falls all over the place.

—Elizabeth

Bizzie

BOXER AND GERMAN SHORTHAIRED POINTER MIX, 1.5 YEARS OLD

DOES SHE HAVE ANY NICKNAMES?
Bizzie Girl, Bizzie Baby

TELL US ABOUT GOTCHA DAY.
I saw "Biscotti" in the photo lineup of the dogs at an at-capacity kennel, and I knew I had to meet her. She has the most beautiful half-brindle face. I had never seen anything like it. She was the first dog we looked at and met as a family, and we fell in love with her right away. She was happy and playful and the most food-motivated dog I'd ever met. We all knew immediately she belonged home with us.

WHAT ARE HER FAVORITE THINGS TO DO?
Bizzie loves to go on long walks, and she has been perfect on the leash since day one. She loves to look out the window of the car. She enjoys laying on the couch and finding the perfect spot . . . which is usually on top of one of our limbs.

DOES SHE HAVE ANY SILLY QUIRKS?
Bizzie likes to lay on top of her people as often as possible. She has recently started hiding toys and snacks under couch cushions and in piles of blankets or laundry. She doesn't like to be left outside alone and needs someone to stand next to her so she can go potty. Every time we come home, I swear our whole house starts shaking because of how fiercely she is wagging her tail.

WHAT DOES SHE MEAN TO YOU?
I recently found out it is unlikely I will be able to have any more children. Bizzie has become my new baby. She seems to have bonded with me just as much as I have with her, and I'm so grateful I was able to find her.

—Kaitlyn

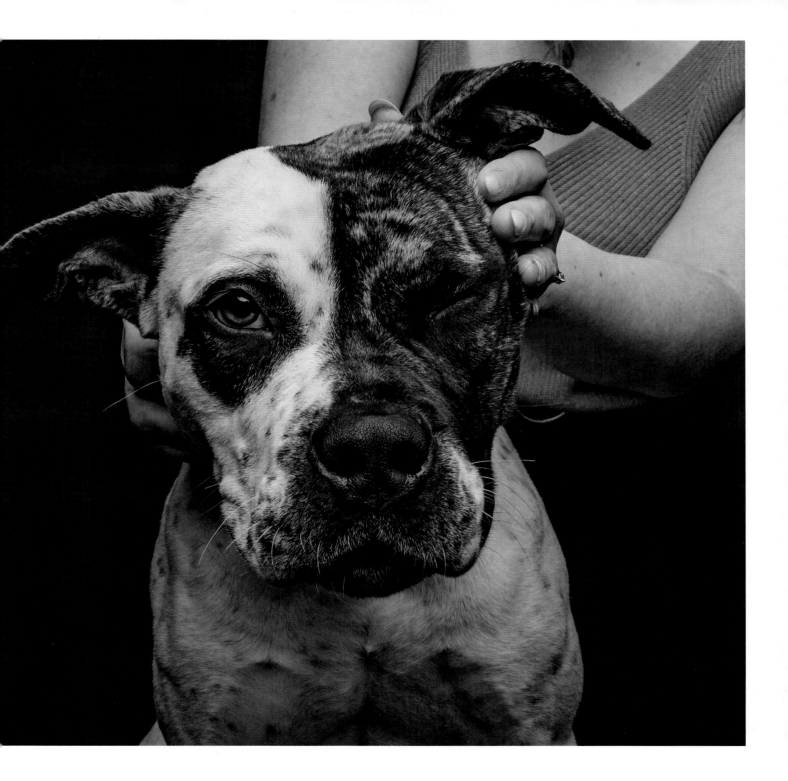

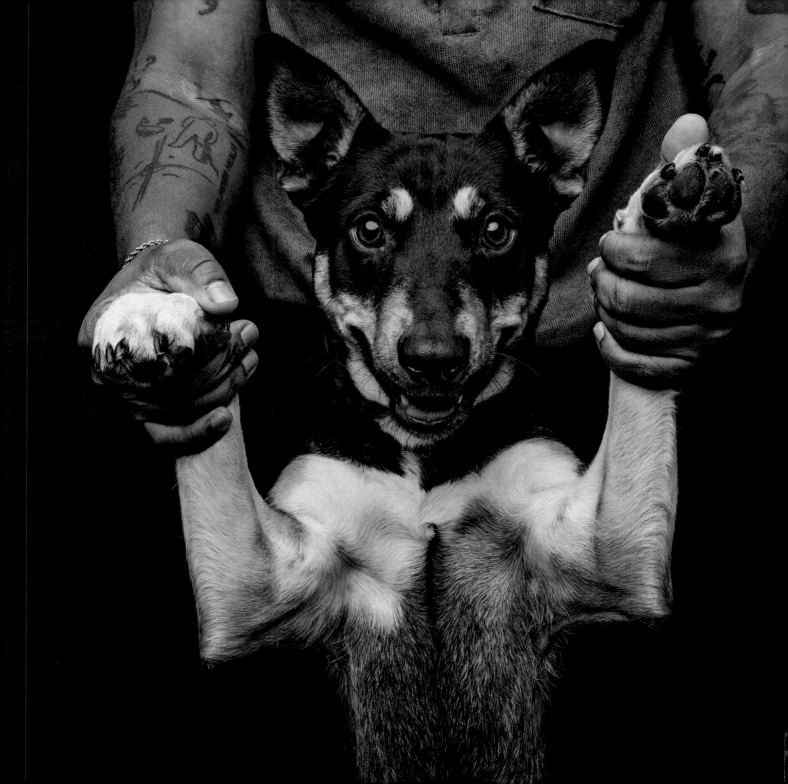

Mowgli

PIT BULL, SIBERIAN HUSKY, AUSTRALIAN CATTLE DOG,
GERMAN SHEPHERD, AND ROTTWEILER MIX, 1 YEAR OLD

DOES SHE HAVE ANY NICKNAMES?
Lil Cactus, Mowgs, Feral Child, Mowgliana, Mo Mo, Queen Cactus, Queenie

TELL US ABOUT GOTCHA DAY.
Mowgli was dumped in the desert near Gallup, New Mexico. She was pretty close to death. I was on a road trip with my other dogs, Milo and Moose (page 148), pulled over to get souvenirs at a random exit, and it was like fate! I found her and put her in my van, and the other pups immediately started caring for her.

WHAT ARE HER FAVORITE THINGS TO DO?
Anything high energy: zoomies, fetch, racing, going on hikes, wrestling. She also loves dressing up and chewing on bones. Mowgli also loves her siblings. Recently I had a backyard jailbreak, and all of the dogs escaped. I found them three streets over, running around and playing together. They stuck together the entire time! They're so close they even sleep on the same bed together every night.

DOES SHE HAVE ANY SILLY QUIRKS?
Mowgli is hilarious! She goes from zero to one hundred in an instant. She's crazy athletic and enjoys vaulting over her siblings and anything in her way.

WHAT DOES SHE MEAN TO YOU?
Mowgli reminds me to be resilient every day. She's been through much and still looks at the world with such beauty. It's so inspiring.

—Noah

Moose

STAFFORDSHIRE BULL TERRIER, CHOW CHOW, SIBERIAN
HUSKY, AND HOUND MIX, 2 YEARS OLD

DOES HE HAVE ANY NICKNAMES?
Moosen, Moosey, Baba

TELL US ABOUT GOTCHA DAY.
When we first saw Moose, he looked so adorable, like a mini Scooby-Doo. He looked so innocent, stoic, and wise. We immediately fell in love and built trust very quickly. Now he's my shadow.

WHAT ARE HIS FAVORITE THINGS TO DO?
Sleeping, sleeping on Dad's feet, sleeping on Dad's lap, sunbathing, listening to music, going on walks and hikes, and dressing up.

DOES HE HAVE ANY SILLY QUIRKS?
Moose loves to hide under blankets. He knows how to enclose himself fully, and he thinks he's invisible.

WHAT DOES HE MEAN TO YOU?
Moose is the most loving and calm spirit I've ever come across. He lost one of his eyes to a cataract as a puppy, but his remaining one expresses so much life! I've never met a more emotional dog. He is my biggest comfort, and having his energy in my life is an incredible gift and an honor.

—*Noah*

"Moose is the most loving and
calm spirit I've ever come across."

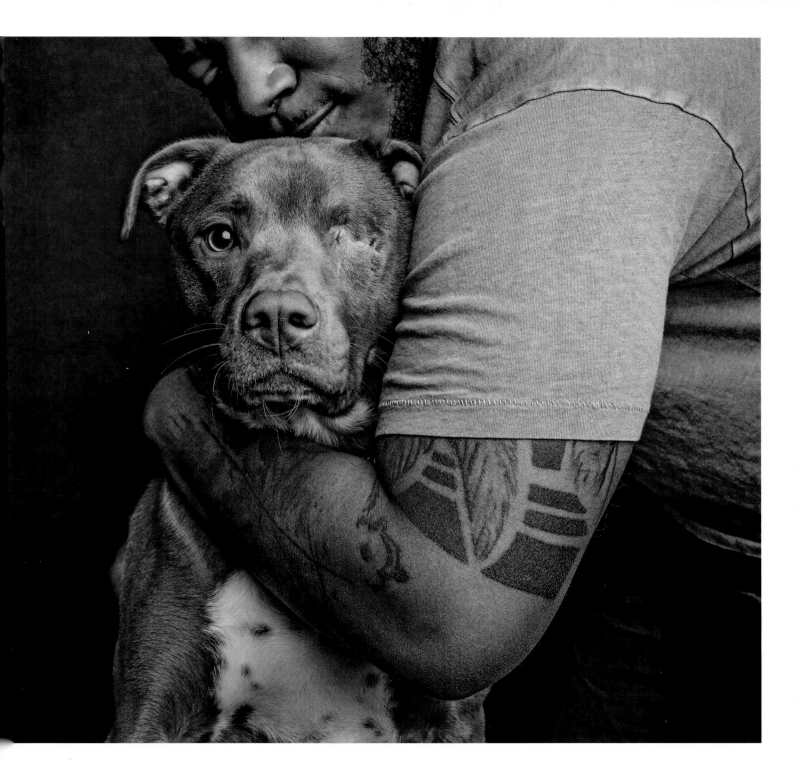

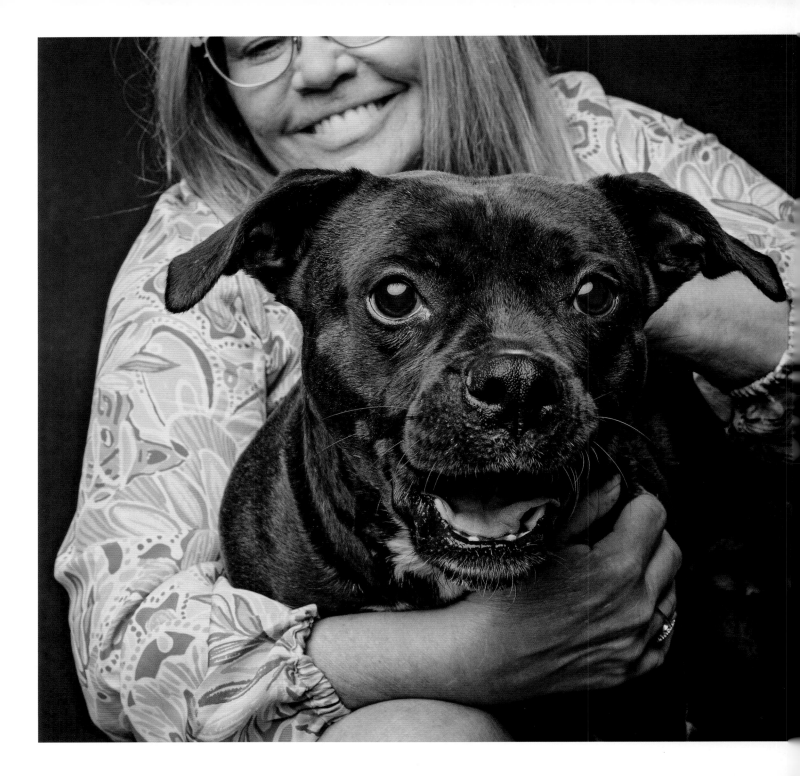

Lola

| BOXER, PIT BULL, AND PUG MIX, 3.5 YEARS OLD

DOES SHE HAVE ANY NICKNAMES?
Loller or Little Fat Black Piggy Dog

TELL US ABOUT GOTCHA DAY.
Bryana Polen at Lake Humane Society posted photos of Lola in her office and said she adored this sweet girl. Her name at the time was Samaria. I found out that Lola had been rescued from a home that had twenty dogs living in cages in the basement. She had recently had five puppies, and they all died. Her story grabbed my heart, and I knew I needed to take care of her and let her experience life as a dog should!

Our first meeting was very mellow. Lola didn't want to get off her bed. (She still doesn't want to get out of bed!) She was super chill and laid-back but finally came over to me, sat in my lap, and looked at me with a face that said, *Will you please take me home?*

WHAT ARE HER FAVORITE THINGS TO DO?
Sleeping, eating, taking walks, and playing with her pittie mix brother, Mulligan!

DOES SHE HAVE ANY SILLY QUIRKS?
Lola snorts when she is in a deep sleep. She tries to play with our Maine coon cat, Gizmo, but is actually scared to death of him! She trots like a dressage horse. She has no neck, which makes her look like a frog. And she is *always* cold.

WHAT DOES SHE MEAN TO YOU?
She means the world to me. We had lost our young pit bull to cancer a few months prior to finding Lola. I knew I needed her to fill the void of our recent loss. Her eyes were so soulful and spoke to me. She needed our family, and we needed her!

ANYTHING ELSE WE SHOULD KNOW?
Lola doesn't have a cranky bone in her body—she loves everyone she meets! She is great with other dogs, too. Despite her living conditions for the first two years of her life (I am not sure that she ever saw snow before we adopted her!) and losing her puppies, she is the absolute sweetest dog! It just goes to show how resilient some dogs are and how appreciative they can be to their rescuers and new family.

—Lisa

Gigi

| PIT BULL, 8 MONTHS OLD

DOES SHE HAVE ANY NICKNAMES?

Gigi Beans, Gi Ju Weej, G Monkey, Gi

TELL US ABOUT GOTCHA DAY.

I met her the first time in my salon. My client was fostering her, and I immediately fell in love. She was such a cuddle bug!

WHAT ARE HER FAVORITE THINGS TO DO?

Gigi *loves* to play catch and sunbathe! She is also a salon dog and loves to greet the guests at the door.

DOES SHE HAVE ANY SILLY QUIRKS?

Gigi makes the funniest noises when she wants something—she is quite the drama queen! She always wants a bite of everything anyone else is eating!

WHAT DOES SHE MEAN TO YOU?

My dogs mean everything to me. They are my sunshine every day and the best therapy.

—Chrissy

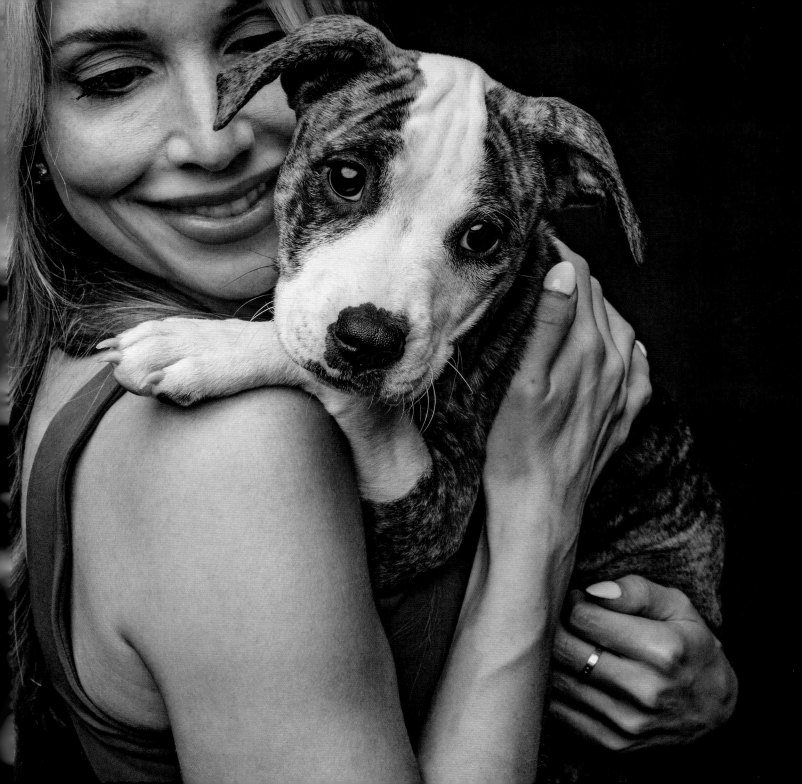

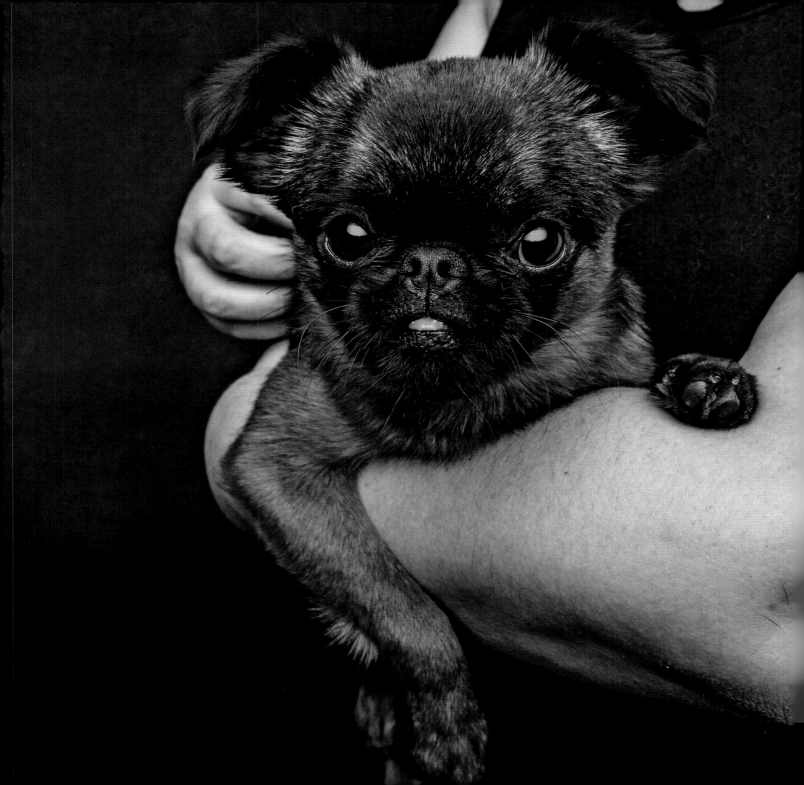

Zoëlla

| BRUSSELS GRIFFON, 1 YEAR OLD

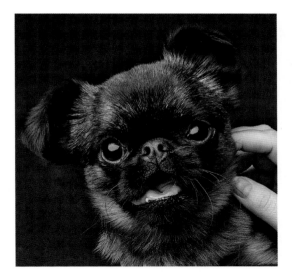

DOES SHE HAVE ANY NICKNAMES?
Zoë, Stinky, Zo-Zo, Little Bean

TELL US ABOUT GOTCHA DAY.
When I first met Zoë, she climbed up on my shoulder and curled up in a ball. It was love at first sight.

WHAT ARE HER FAVORITE THINGS TO DO?
She is very sweet, endlessly curious, and playful. She loves going to the dog park, camping, laying in the sunshine, meeting new people—especially kids—and snuggling.

DOES SHE HAVE ANY SILLY QUIRKS?
When she is excited to meet someone, she will do a little dance. She also loves to hide under the couch and peek her head out. She is a very picky eater and has expensive taste!

WHAT DOES SHE MEAN TO YOU?
Zoë is my world! She is always teaching me about unconditional love, the importance of play, and to not take life too seriously.

—Alycia

"She is always teaching me about unconditional love, the importance of play, and to not take life too seriously."

ACKNOWLEDGMENTS

Thank you to everyone who participated in this book with their dogs.

Thank you to Gibbs Smith for allowing me to share my photography and love of rescue dogs with the world.

Thank you to my family, Kristen, Evie, Beck, Leo, and Kensie.

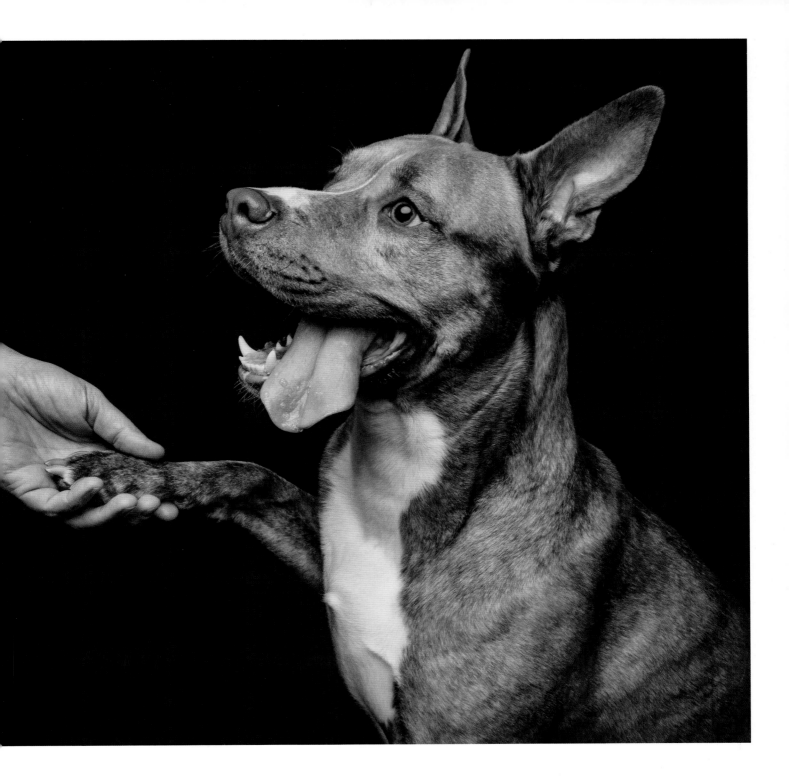

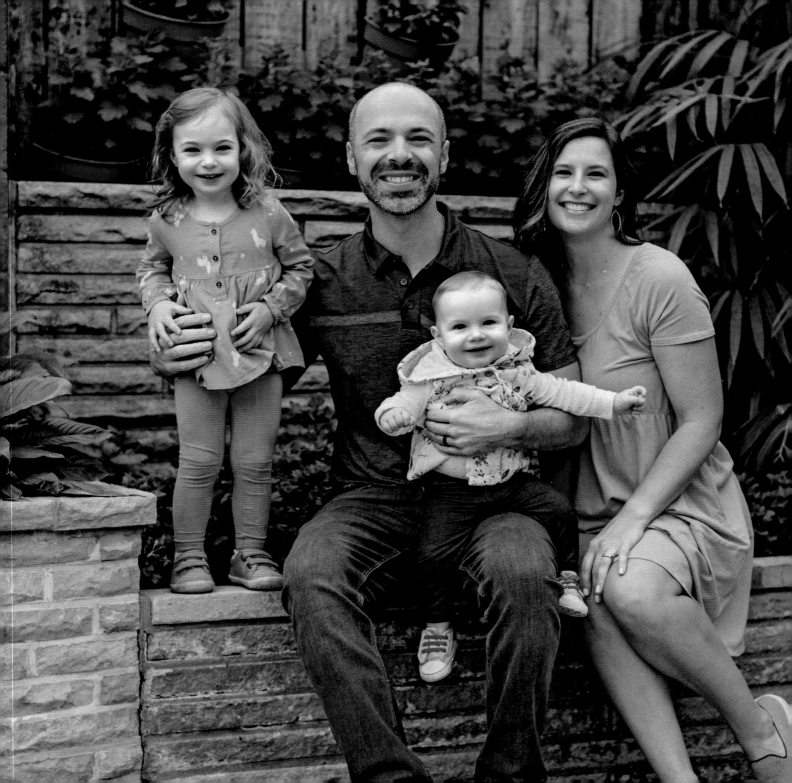

ABOUT THE AUTHOR

Greg Murray is a portrait, lifestyle, commercial, and editorial animal photographer. He is also an advocate for rescue animals, especially pit bull type dogs. His previous titles include *Peanut Butter Dogs* (2017), *Pit Bull Heroes: 49 Underdogs with Resilience and Heart* (2019), and *Peanut Butter Puppies* (2021). His work has been featured in Huffington Post, Today, *Daily Mail*, *Elle*, *People*, and other media outlets throughout the world. He lives near Cleveland, Ohio, with his wife, Kristen, their daughters, Evie and Beck, and their two rescue dogs, Leo and Kensie.

@thegregmurray | www.gmurrayphoto.com

Also Available